*This volume is one of a series devoted to the art and technology
of photography. The books present pictures by outstanding
photographers of today and the past, relate the history
of photography and provide practical instruction in the use
of equipment and materials.*

LIFE LIBRARY OF PHOTOGRAPHY

Travel Photography

Revised Edition

BY THE EDITORS OF TIME-LIFE BOOKS

TIME-LIFE BOOKS, ALEXANDRIA, VIRGINIA

© 1982 Time-Life Books Inc.
All rights reserved.
No part of this book may be reproduced in
any form or by any electronic or mechanical
means, including information storage and
retrieval devices or systems, without prior
written permission from the publishers, except
that brief passages may be quoted for reviews.
Revised Edition. First printing.
Printed in U.S.A.
Published simultaneously in Canada.
School and library distribution by Silver Burdett
Company, Morristown, New Jersey 07960.

For information about any
Time-Life book, please write:
Reader Information, Time-Life Books,
541 North Fairbanks Court,
Chicago, Illinois 60611.

TIME-LIFE is a trademark of
Time Incorporated U.S.A.

Library of Congress Cataloguing in Publication Data
Main entry under title:
Travel photography.
 (Life library of photography)
 Bibliography: p.
 Includes index.
 1. Travel photography. I. Time-Life Books.
II. Series.
TR790.T7 1982 770'.28 81-21206
AACR2
ISBN 0-8094-4406-2
ISBN 0-8094-4405-4 (lib. bdg.)
ISBN 0-8094-4404-6 (retail ed.)

ON THE COVER: Pictures of a brilliantly
costumed young woman from the
southern tip of the Arabian peninsula (by
Pascal Maréchaux) and of the rain-
washed Parthenon at night (by Richard
Misrach) represent successful efforts
to deal with two of the challenges the
traveling photographer faces: capturing
intimate glimpses of reticent local
people, and creating personal views of
much-photographed monuments.

V.S.W.
Gift of publisher
2 May 1983

Contents

All too often the traveling photographer, looking at his tour pictures back home, finds that the fond memories he had hoped to preserve on film have faded as rapidly as a winter vacationer's tan. He wishes he had been better at capturing that atmosphere, at evoking whatever it was that made the visited place so captivating at the time—in short, at bringing the travel experience back alive. The purpose of this volume is to help him do that.

The traveler with the camera faces some special obstacles he does not have to cope with at home. He cannot carry as much equipment. He spends a great deal of time getting to his desti-nation and an equal amount of time getting back. He may be frustrated by the fleeting opportunity, particularly when it is complicated by bad weather.

Yet he can pack a single camera bag with equipment sufficient to cover nearly any situation he will encounter. He can take some excellent pictures en route, from plane, train or car. And, most of all, once he fully comprehends the sense of the place, he can learn how to communicate that sense fully in his photographs.

Usually the feeling of place and atmosphere is best conveyed by color. Most traveling photographers tend to think in terms of color, yet a black-and-white picture often expresses more of the traveler's sensations than color can, and pages 107-126 demonstrate how professional photographers have used monochrome to advantage.

The chapters in this book combine the advice of professionals with examples of pictures from their travels, and offer their tips on everything from what to take along and how to handle lighting problems in dark church interiors to what times of day to take certain pictures, and even how to change bad weather from a liability into an asset. How well that advice can be applied is shown by the fact that many of the pictures included are by amateurs.

The Editors

Have Camera, Will Travel **1**

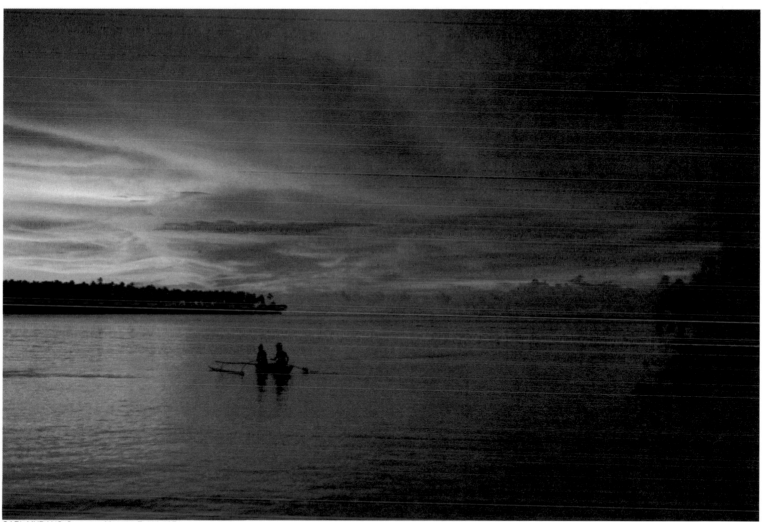

CARL MYDANS: *Sunset at Moorea, Tahiti,* 1971

An Expert's Advice to the Tourist-Photographer

Carl Mydans, a staff photographer for Life magazine from 1937 to 1972, here draws on his long experience in traveling with a camera to offer practical advice on taking pictures away from home that will be memorable photographs long after the trip is over.

One day when I first traveled to New York, I suddenly glimpsed a wondrous spectacle: Through the fiery, backlit cables of the Brooklyn Bridge a sunset transformed the city into a glowing mirage. Slowly it grew into a colossal Stonehenge, drenched in red. My hands trembling, I ran this way and that, looking through my finder, trying to catch in my camera what had caught in my heart. As I write this—four decades and hundreds of thousands of negatives and transparencies later—with my traveling case packed with fresh film and my cameras checked anew, my spirits are rising as they do whenever I set out on another trip. For ever since that vision in New York, I hope for another such sight wherever I go, one that will set my hands trembling as I raise my camera. I have found them often enough to make traveling—with camera—the most satisfying activity in my life.

Most people seem to feel the same way. We travel not just to be on the move, but to take pictures along the way. It is not hard to understand why, for pictures of travels allow us to relive our experiences. Looking at the image of a famous view that seemed thrilling when it was first seen rekindles that thrill; when we study the picture of the unexpected street happening that offered a sudden insight into a country, we recall our pleased surprise all over again; even when we see ourselves or our traveling companions trapped in some predicament with luggage or language, we enjoy in retrospect what seemed at the time an awkward plight.

Each traveler's record of his trip is a personal expression, catching the flavor and drama of his own experiences. No two people see things exactly alike, and however many are standing together clicking away at the same subject, their pictures will all be different. Millions of tourists have photographed Mount Fuji and the Eiffel Tower, but I have never seen precisely duplicated pictures of either one. Just as that unique view of a phantom New York was waiting for me on the Brooklyn Bridge many years ago, such a picture-moment may be waiting anywhere for anyone. To be ever hopeful of coming upon it is the thrill of traveling with a camera.

Because I have been traveling for years and pictures have been the heart of my journeys, friends leaving for a trip frequently ask me what to photograph and what cameras and lenses to use. Be assured that expensive equipment is not necessary; an outfit that provides flexibility at home, such as the one shown on page 81, will do so away from home.

Much more important than the equipment is the photographer's familiarity

with it. Know the capabilities of lenses and film, and avoid buying anything new just before setting off. The temptation to get a brand-new camera or extra lens to take on a trip may be almost irresistible, but unless the new equipment has been tested at home, the results are likely to be frustrating. A woman I met in Thailand came to me near tears because, although she had thought she understood everything about her new camera, she could not remove the exposed film and reload it. After she shot one roll, she missed the pictures that came later on a tour through Bangkok and the countryside—and they were some of the best opportunities of her trip.

It is also wise to decide before leaving home how black-and-white pictures will be handled. Most travelers shoot only in color, and that is generally a mistake because some scenes come across best in monochrome. Yet using both types of film raises a problem of its own; each calls for a different artistic approach, and the process of thinking out pictures is different. It is surprising how photographic capability is impaired by switching back and forth from one to the other.

When a couple travels together, one might decide to shoot color, the other black and white. The decision might be made on the basis of differences in taste; on pages 107-126, for example, there are some travel photographs that are better for having been taken in black and white. Even color film alone can pose a difficult choice: In some locations, a mixture of daylight and artificial light may raise the question of whether to use tungsten or daylight film. Do not worry about it; shoot whatever is in the camera at the time. The result may not be exactly true color but usually the difference will be so slight that everyone will be delighted with the pictures.

The most important advice I can give on equipment has nothing to do with the technicalities of emulsions or optics. It is simply: Carry a camera at all times. The rule applies from the beginning of a trip to its end, for many memorable pictures can be made en route—at terminals, aboard planes, ships, cars and trains. It is not commonly realized that train travel in particular provides excellent opportunities to take exceptional photographs. Trains usually ride higher than the areas they pass through and the view from them is often commanding, surpassing what can be photographed from ground level. Pictures taken from trains provide a kaleidoscope of scenes: countryside and city, homes and factories. Not only are there open views of fields, rivers and mountains, but there are also chances to look behind the scenes, to photograph the backyards—the underside of a country's life that might be missed traveling by the plane that lands at the airport in the city's outskirts or the automobile that follows the scenic highway into the center of town.

Shooting from a moving train may seem impossible to the traveler. Actually it only takes a little practice and is a fine game of anticipation. At first the

fleeting, imperceptible delay between what the eye sees and the finger snaps may result in some surprises: The green Malaysian rice field may come out a blurred bridge railing; and the Thai temple blinking in the sun may turn into an embankment of weeds. But it takes only a little practice to learn to anticipate and, even in such brief moments, to select. Do select, however; snapping away feverishly will only waste film.

The injunction to keep a camera at hand applies more forcefully at the trip's destination. Remember that it is a mistake to leave the camera in the hotel on rainy or overcast days; frequently weather can add an extra element of mood or atmosphere to the picture. And remember especially that a scene worth photographing is seldom the same when returned to later. Often it is not there at all, so it should be photographed at this opportune moment. Other scenes may improve as they change — with changing light or weather — in which case patience will bring even greater rewards. I recall once taking pictures on the Tahitian island of Moorea, where the afterglow of sunset colors the sky and the sea with incredibly beautiful reds and oranges. Having chosen my area for a picture, I returned every evening at sunset. But sometimes clouds obscured the sun, while at other times the sea was empty. Then one evening all the components came together: the sky and clouds were tinged with those gorgeous colors, the afterglow spread across the sea, and at that moment two Polynesian women in a dugout paddled into the scene. In that instant I had the photograph I had been hoping for *(page 11)*.

Glorious panoramas can be found almost everywhere, and one way to locate them is to buy picture postcards. Local photographers may not have the best sense of composition; but they have scouted the area for years, and their selection of positions can provide a quick choice of prospects. In fact, a postcard picture can provide a challenge as well. The traveler with a sharp eye and a keen imagination can get considerable satisfaction out of taking an even better picture. Some striking examples are on pages 202-216.

I think it is a mistake, however, to concentrate only on the panoramas. The small things in a scene are often equally interesting. A texture-rich close-up of a weathered fence or of the eroded bricks in an old wall might highlight the character of a country or say something crucial about its culture. Details are equally important in pictures of people. The bent body of the old peasant stooping in the doorway might be no more dramatic than a close-up of his gnarled hands. The picture of the cobbler working at his dusty bench might also call for a look at such details as the shoe he is making, the odd-shaped tools lying in the leather scraps on the ground, or even the worn sandals on his own feet. Such a sequence — what the professional photographer calls ''taking the scene apart,'' or ''the one-two-three'' — often can tell far more about the subject than any one picture.

People are an essential ingredient in travel pictures, for they can impart at least as much local flavor as a photograph of a place; and often they provide the personal excitement that the visitor wants most to preserve on film. There are two approaches to photographing people: that of the "invisible witness," who waits for his subjects to compose themselves into a picture he feels is right, and that of the photographer-director, who takes charge of his subjects and moves them around until he has them composed the way he wants them. Most travelers use the first approach to catch informal glimpses of street life and market scenes, but even in those situations it is sometimes wise to ask people if they will let themselves be photographed—especially if the photographer senses that they are becoming suspicious or resentful.

Anyone who has ever had this request made of him will have an idea of their reaction: perhaps embarrassment, amusement, annoyance, or occasionally a feeling of obligation to international goodwill. In Japan it is not uncommon for an American to be asked to join a group of Japanese tourists standing stiffly in front of a giant Buddha while their companion takes a picture of his friends and the strange-looking gaijin in their midst. I have been in this situation a number of times myself, and I know the feeling of the interminable wait while the smile grows wooden on my face.

In front of a camera most people are stiff and self-conscious unless the photographer can provide the spirit to enliven them. Putting some life into their actions and expressions can be accomplished even among foreigners who speak a strange language. Enthusiasm and good nature are a universal language; surprisingly often, people will do their best to respond.

Sometimes, however, even the most engaging spirit is not enough to relax subjects. The simpler a people's society, and indeed the more eager they are to accommodate a stranger, the more rigid they may become before the camera. Some people still seem to believe that if they twitch a muscle they will ruin the picture. I have found that one way of getting around this natural tendency to freeze up is to snap the posed picture and then, lowering my camera, to thank my subjects warmly for their kindness. They almost always thank me in return. It is at this transient moment, when they are relaxed and smiling, that I take the picture that shows them as they truly are.

It is necessary to remember, however, that there are many people who, for deeply personal reasons, object to having their picture taken. To try to force such people is not only futile but unkind. Some object to being photographed because they are ashamed of their clothes or surroundings, some because of religious taboos or even because they are convinced that a copied image of themselves might be invaded by evil spirits. Once while I was taking pictures of a Chinese shopkeeper and his wife in Djakarta, their daughter suddenly stepped in to be photographed between them. Instantly

the mother flew out of the picture. "No! No!" she protested. "If you photograph three people together, one of them will soon die!"

At other times the reasons are more pragmatic. Once in Yugoslavia I stopped to take a picture of a group of farmers pitching hay by the roadside. The men had their trousers tucked into high boots and the women wore kerchiefs on their heads and bright-colored skirts. A bottle of wine stood by the cart wheel, and the mood was festive. As I approached, one of the women waved me off angrily, and when I stopped, perplexed, she walked away. The others laughed. "Her husband doesn't know she's here," they explained.

It is important to proceed carefully on occasions like this when people show a reluctance to be photographed, for the camera does at times invade privacy, and accordingly the burden of good manners is on the photographer. Chapter 6 has further suggestions for getting enjoyable pictures of people—enjoyable to the subjects as well as the visitor.

Courtesy in choosing subjects for pictures may not suffice in some lands, however. While tourists with cameras are now welcomed nearly everywhere, their reception can chill quickly when they focus on certain kinds of subject matter. In some places, particularly in the countries of Eastern Europe, the unwarned traveler may not always recognize the scenes that it might be imprudent to photograph. From my own experience, I would say that it is best to avoid the following subjects in those regions: all queues, because the authorities in these countries are sensitive about publicizing any shortages of consumer goods; all military institutions and installations; seaports; railroad junctions; all views from airplanes; views from heights in industrial cities (in military parlance known as "bomb-folder pictures" because they are the kinds of pictures bombardiers use to identify targets); drunks (I learned to make it clear that I was not using my camera when I saw one coming); slums or any other subject that might reflect social problems and therefore be deemed embarrassing to national pride. I was once detained for taking pictures of an ancient church that had been blown into dramatic tatters by years of storm and neglect. (For further suggestions on how to cope with limitations that various countries place on tourist photography, see pages 86-89.)

Elsewhere I have found few restrictions other than those concerning military installations, which are common in most countries. However, one foreigner who was recently allowed to travel to North Korea tells the following story: Accompanied by a guide, he took some pictures of a slum in Pyongyang and left the exposed film cartridge in his room. After he returned home and had the film developed, he found that his exposed roll had been replaced with another. This one showed nothing but monuments.

Such incidents are blessedly rare, for photographic restrictions have disappeared almost completely in recent decades. Nowhere is the change more

dramatic than in Japan. There, before World War II, a visitor's cameras were most often taken from him or sealed; when he was allowed to use them, he was watched while taking pictures and was required to have his film developed and to clear the negatives with a censor before he could leave. Today, of course, there are no longer any such restrictions, and the country is overrun with photographers, Japanese as well as visitors.

The new freedom to photograph wherever and whenever there is a good picture in turn presents a challenge to the traveler. In all the variety of permissible subject matter, what should be taken? The best answer is not a new one: The greatest pleasure comes from pictures of things that suit the photographer's own personal interest. The student of history might seek out ancient locations evocative of great events—the haunted rooms of Holyrood Palace in Edinburgh, the crumbling ruins along the old Appian Way in Rome, the fields of Waterloo in Belgium. An art lover might concentrate on the frescoes inside Romanesque cathedrals, a gourmet on early-morning market places or on the restaurants that serve memorable food. I know of one traveler who photographed every meal he ate on his trip; I know another who for years has taken pictures of every hotel room he stayed in.

I once had an English professor who said that when he traveled he studied—of all things—apples and cheeses. They took him everywhere, and transformed him from an idle voyager into a man with a mission. It was this special interest, he said, that made him a citizen of the world, a member of every society he visited. I pass his example on as my most important advice on traveling with a camera: The traveler with a camera should plan his trip around whatever constitutes his own particular apples and cheeses. *Carl Mydans* □

The Traveler's Eye

The qualities that make a good travel photographer are also those that make a good traveler: curiosity about the infinite variety in the world, appreciation for other cultures, and an eye for scenes that are unusual, telling or incongruous. The best way to develop such qualities is, apparently, to travel. Few of us can fully appreciate the visual possibilities in our own environment: Our eyes become so attuned to their usual diet of sights that a remarkable candelabra-like tree across the street or an amusing confrontation between a shaggy dog and a neighbor's long-haired child goes unnoticed—or, if noticed, goes unphotographed.

But once we assume the role of traveler—whether to distant lands or the nearest state—our senses seem sharper and our perceptions clearer. These faculties can be heightened by practice even on short jaunts. And they are worth developing, for they make the difference between static, ordinary pictures destined to languish in a drawer and those that vividly recall the experiences and sensations of travel. Moreover, once the faculties are developed, they can be applied in taking photographs closer to home, spotting the odd, amusing or visually arresting features of one's everyday environment.

While the vivid travel picture cannot often be grabbed on the run, it is well worth stalking. When you arrive at a new place take a leisurely walk around, or a tour-bus ride, with camera in hand, of course, in case something strikes your eye, but not with any feeling that you *must* get pictures now. At this point it is reconnaissance that you care about.

Pay close attention to what is happening, and make written or mental notes about what ideas to follow up. The bustle at a construction site, the dickering at a produce market, the bottlenecking of traffic at a bus intersection, even the way local people use a park or playground—let nothing escape your eye. Then when you return for picture taking you will have a good idea where the action is and what vantage points to pick—so as to get not any old picture, but a memorable one.

The photographers represented on the following pages, several of whom are amateurs, had two things in common as they traveled: They kept their cameras loaded and their eyes wide open. None of the pictures was posed or contrived; all the situations were there for the photographer to observe or even, as in the case of the ceremonial spectacle at right, to anticipate.

What makes each picture unique is that the photographer recognized a special quality in the scene that would forever recall some aspect of the place he was in—whether it be the incongruity of two massive moving vans afloat on the Grand Canal in Venice *(page 29)*, the strange juxtaposition of Indian tepees on a camping ground at Pendleton, Oregon *(pages 30-31)*, or the awesome vista of a mountain village rising out of a barren Moroccan landscape *(pages 26-27)*.

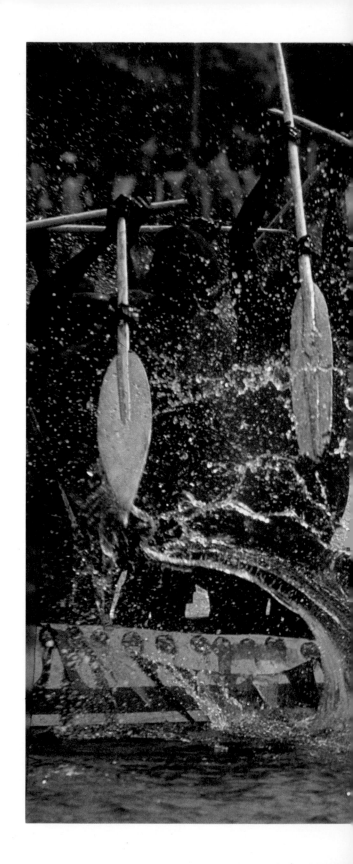

Nigerian canoeists splash with their paddles in a traditional commemoration of a long-ago victory in battle. The ceremony was part of a huge regatta in Lagos that climaxed a multinational festival of African culture. Such occasions offer the traveling photographer all the visual rewards of dazzling pageantry, and sometimes an insightful glimpse into the people beneath all the festive finery.

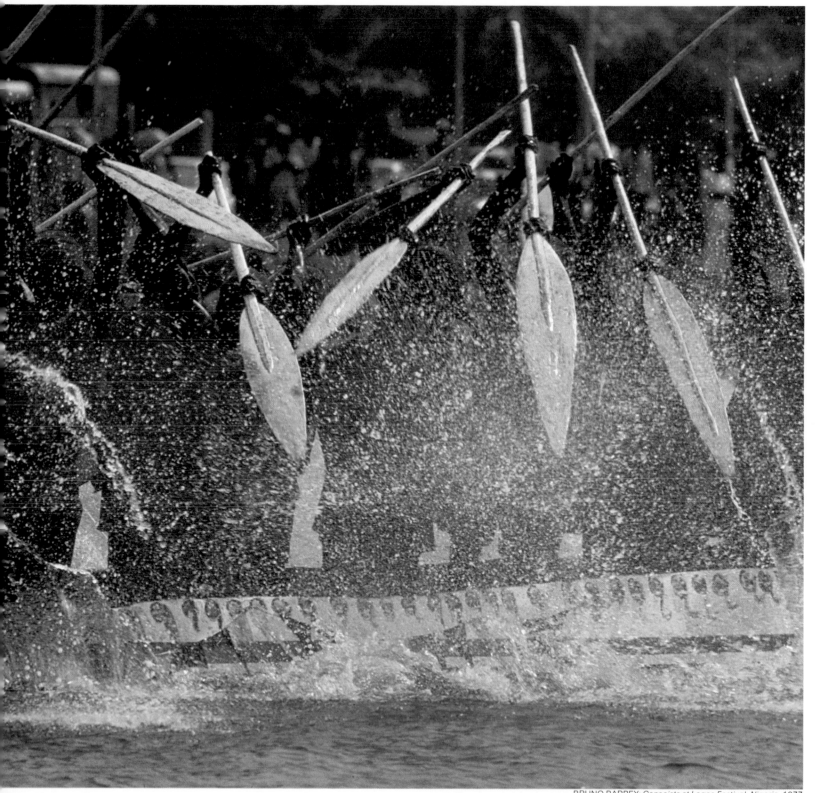

BRUNO BARBEY: *Canoeists at Lagos Festival, Nigeria,* 1977

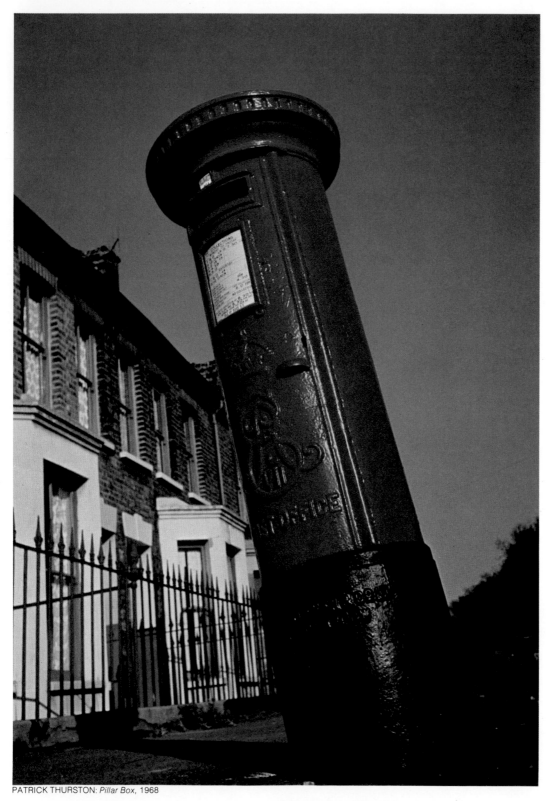

PATRICK THURSTON: *Pillar Box*, 1968

The crazy tilt of an English pillar box adds a note of whimsey to an otherwise commonplace street scene in Greenwich. The photographer came across the precariously balanced mailbox unexpectedly, and deliberately exaggerated its leaning-tower appearance by using a wide-angle lens and shooting from an extremely low angle.

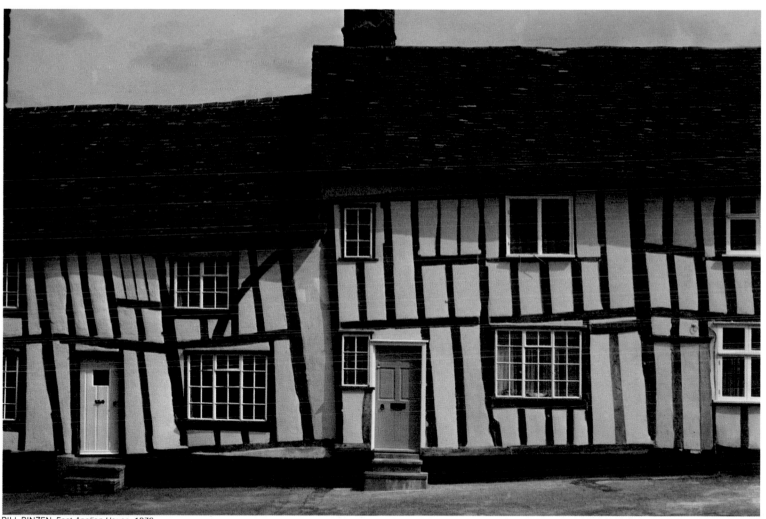

BILL BINZEN: *East Anglian House,* 1970

There is no scarcity of delightful half-timbered Tudor houses to photograph in England. But there cannot be many that look as amusingly tipsy as these. The fact is that these houses, though four centuries old, are still remarkably sturdy and livable. Modernizing them with perfectly squared-off doors and windows has only served to accentuate the casual construction typical of 16th Century homes—and to help the viewer realize where and when the picture was taken.

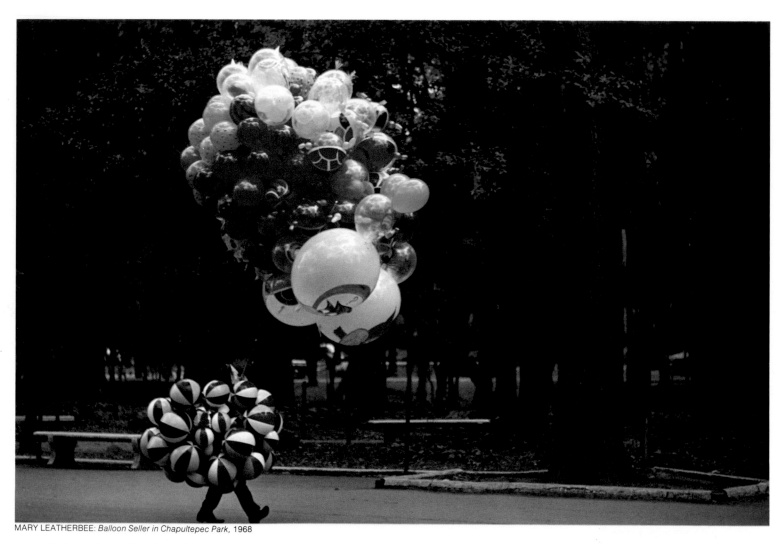

MARY LEATHERBEE: *Balloon Seller in Chapultepec Park,* 1968

*Sundays in Mexico City mean Chapultepec Park,
and Chapultepec Park means balloons. Nearly as
many glistening balloons swing through the park
as children, and the brightly colored round
shapes are an out-of-the-ordinary reminder of
local custom. To capture on film this memory of a
Mexican Sunday, the photographer had to arrive
early one overcast morning, before the balloon
vendors were sold out of their floating stock.*

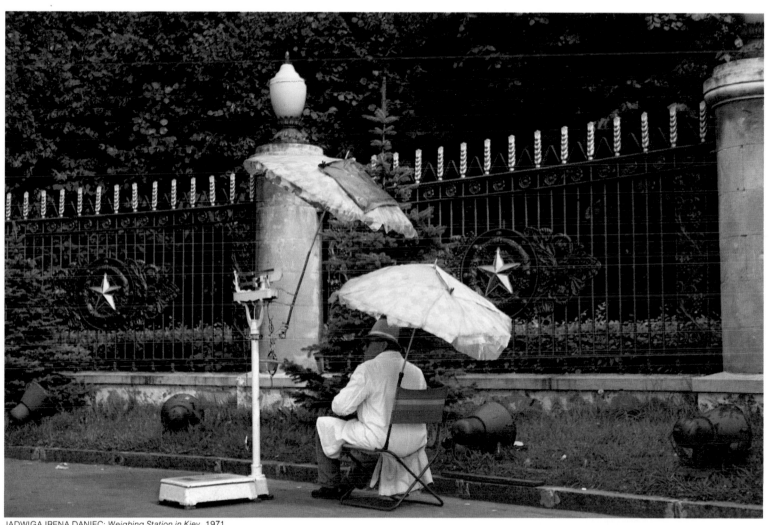

JADWIGA IRENA DANIEC: *Weighing Station in Kiev*, 1971

If no one in calorie-conscious Kiev is going to use this shiny white scale, who can blame its attendant for taking his ease in the shade of his umbrella? This amusing vignette was shot on the run: the photographer had just time enough to focus and snap the picture before her tour moved on. Throughout the trip she had kept her camera set at f/8 and 1/125 second; fortunately, as here, the light was consistently good.

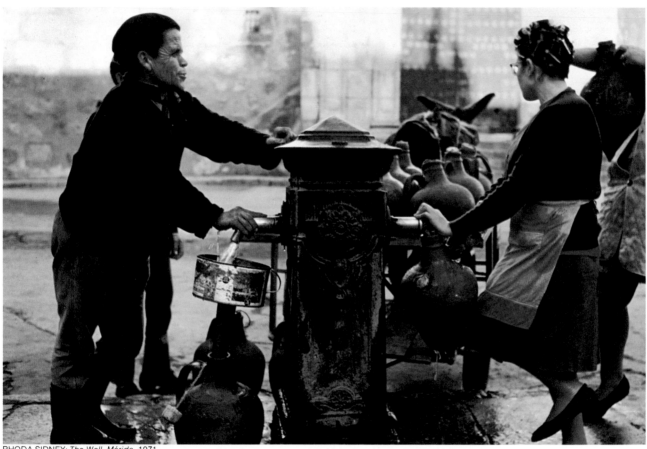

RHODA SIDNEY: *The Well, Mérida,* 1971

*By itself, the cast-bronze public well in the small
city of Mérida has little to recommend it. But it
does take on new interest when photographed as
a center of Spanish life. Here, the photographer
noticed a workman who was more intrigued by the
housewives in hair curlers than by his own chore.*

Few foreigners traveling in Spain venture onto the local buses that rumble from town to town. But anyone who does — like Robert Tschirky — never forgets the experience. He spent some time talking to the farmers who were loading a bus with their belongings — including a newly purchased fat pink pig — at the end of a market day. Once they got used to the photographer's presence, they lost their self-consciousness and he was able to get a remarkably evocative glimpse of street life.

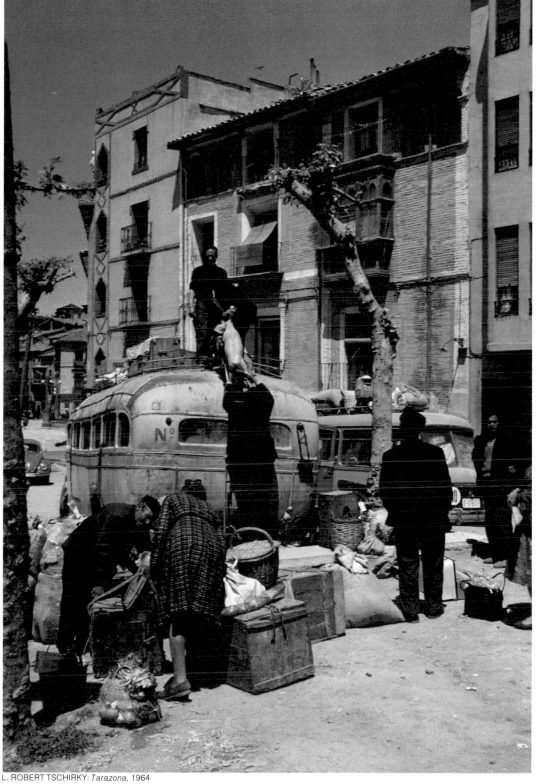

L. ROBERT TSCHIRKY: *Tarazona*, 1964

On the steppes beneath Morocco's High Atlas mountains, members of several Berber tribes walk the path that leads to the village of Imilchil during its annual festival. The compressed perspective of a 200mm lens brings the people and the buildings closer while still showing the expanse of barren land that sets the village in majestic isolation.

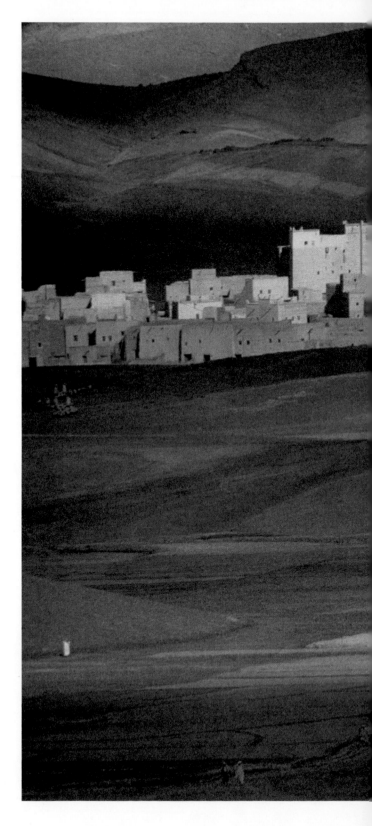

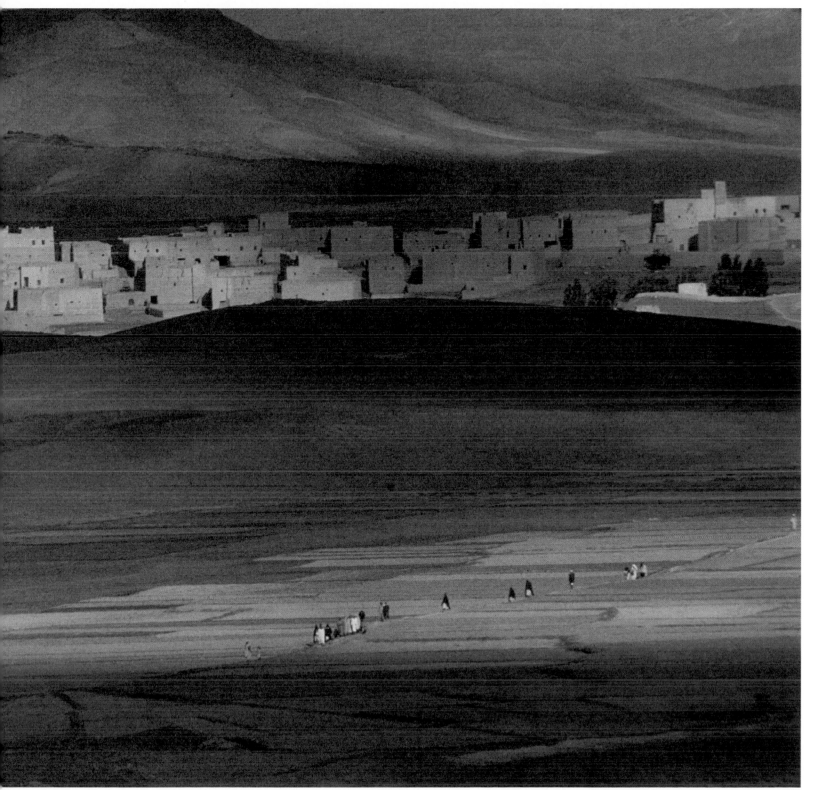

HARRY GRUYAERT: *Mountain Village in Morocco,* 1975

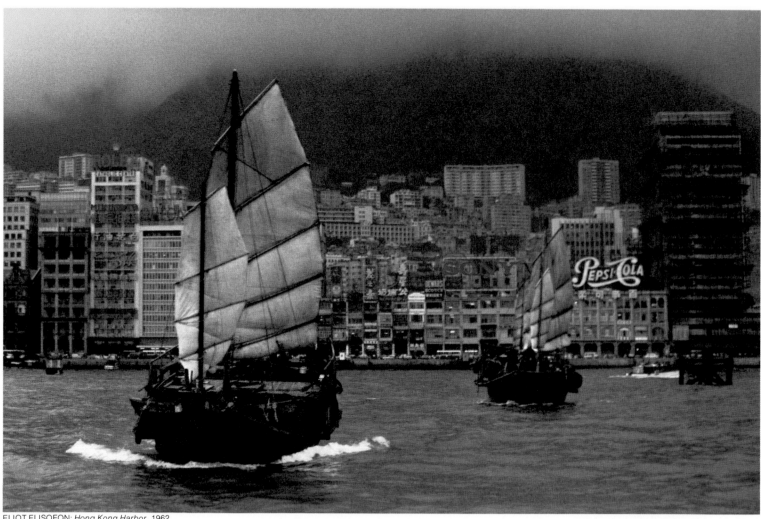

ELIOT ELISOFON: *Hong Kong Harbor*, 1962

Surrounded by picturesque old junks in the middle of Hong Kong Harbor, Life photographer Eliot Elisofon noted the garish incongruity of Western advertising signs punctuating the high-rising façade of the Oriental city. Instead of eliminating the signs from the picture, he actually made use of these intrusive notes to heighten the anachronistic charm of the junks.

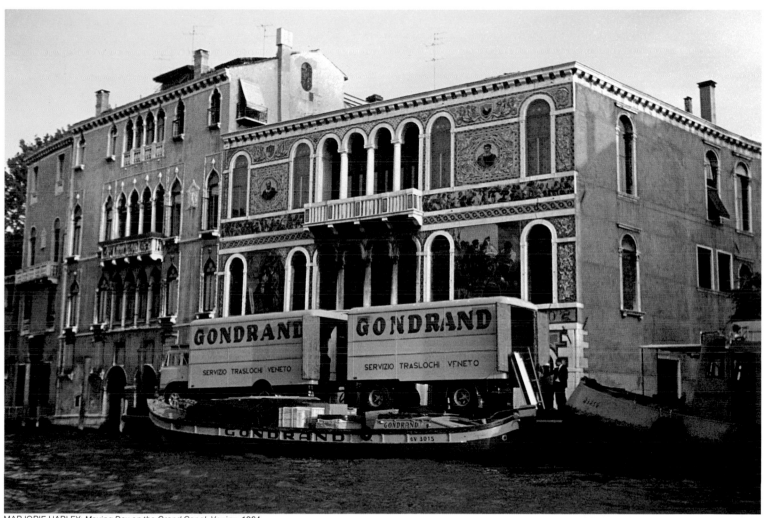

MARJORIE HARLEY: *Moving Day on the Grand Canal, Venice, 1964*

Sometimes a photographer can make up a lost chance: Marjorie Harley, passing an elegant Venetian palazzo on the Grand Canal, was enchanted by the building's frescoes. Unhappily, her camera was back at the hotel. So the next day, camera in hand, she returned, to find it was moving day. Although this was not the picture she had intended, it illuminates life in a canal city.

As dusk settled along the Umatilla River in Pendleton, Oregon, Dan Budnik photographed this improbable scene of Indian tepees pitched near a camping area, with the lights of camper trucks and town-dwellers' homes in the background. The occasion for this uniquely American oddity was the annual Pendleton Roundup, part rodeo, part carnival, which brings Cayuse, Umatilla and Walla Walla families from their reservations to dance, camp out in their tepees, show off their feathered headdresses, and otherwise act out their ancestral customs for photographers and other visitors.

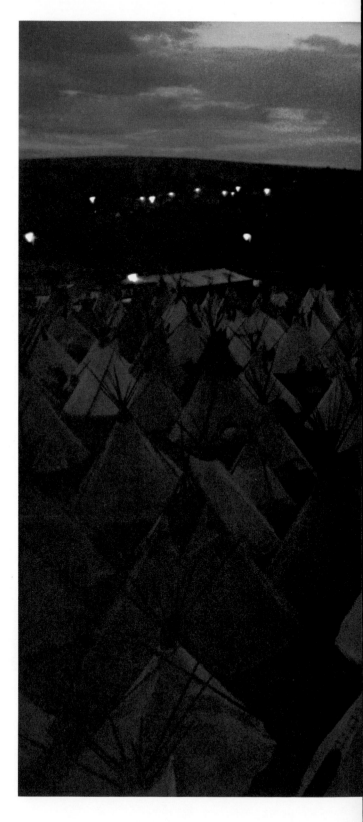

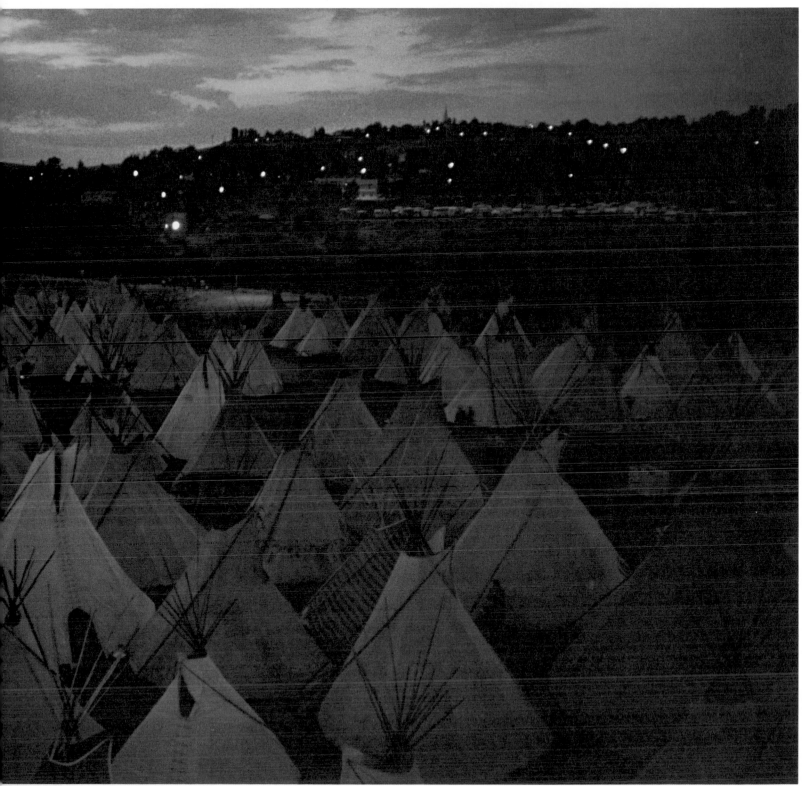

DAN BUDNIK: *Tepees along the Umatilla River,* 1969

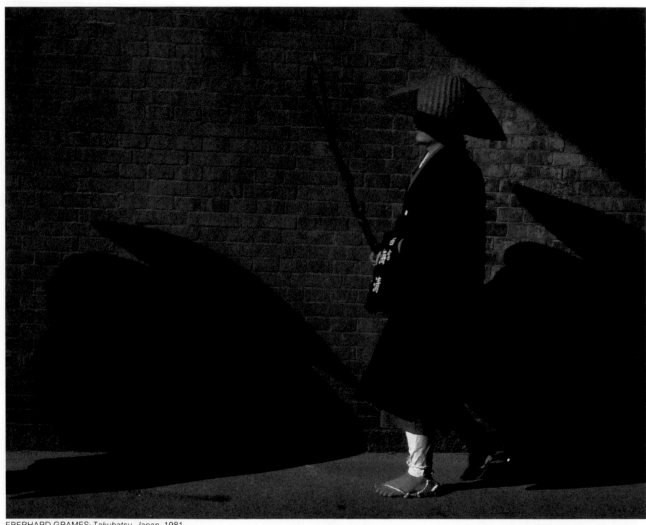

EBERHARD GRAMES: *Takuhatsu, Japan,* 1981

Outside the wall of a Japanese monastery, a Zen
Buddhist monk walks in a ritual begging procession
that is called takuhatsu, soliciting alms for the
support of the monastery. The shadows cast by the
early morning sun surround the black-robed
mendicant and turn this simple portrait into an
intriguing study of repeated shapes.

Incorporated into a dazzling complex of mirrored ▶
arches, pedestrians cross Venice's flooded St.
Mark's Square, one on a catwalk, two others on
the wet pavement. The vertical pattern created by
the reflection—and framed by two columns
through which the picture was taken—gives the
much-photographed square a fresh look.

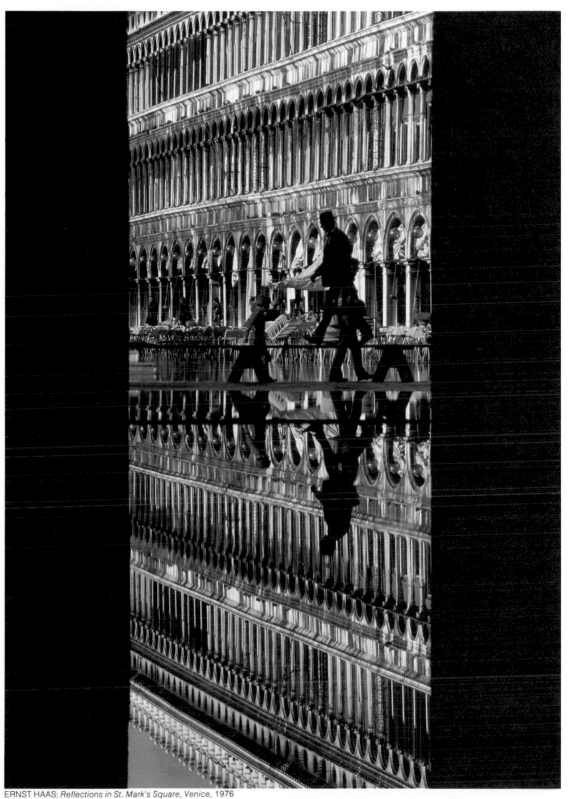

ERNST HAAS: *Reflections in St. Mark's Square, Venice,* 1976

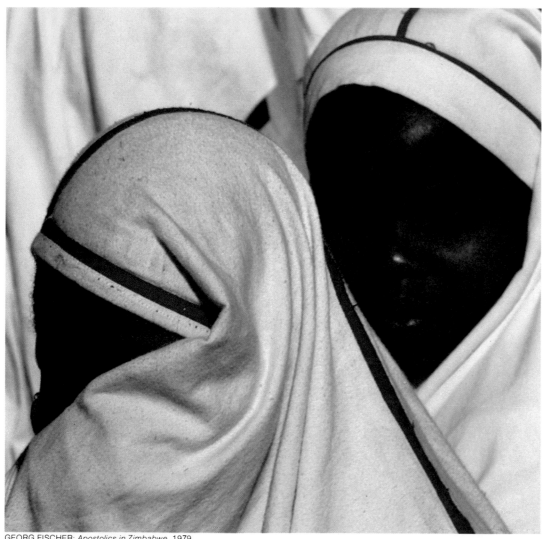

GEORG FISCHER: *Apostolics in Zimbabwe, 1979*

Two veiled young members of the Apostolics, a Christian sect with followers throughout southern Africa, are singled out from a crowd at a large gathering of the faithful in Zimbabwe. A telephoto zoom lens enabled the photographer to stand more than 30 feet from his subjects and still fill the frame with their partially hidden faces.

Five brightly costumed young women hide their faces from the camera as they rest by a crumbling wall during the spring festival in the ancient Moroccan city of Marrakech, celebrated crossroads for desert caravans. A universal note is struck in the exotic scene by the subjects' giggling embarrassment at being photographed.

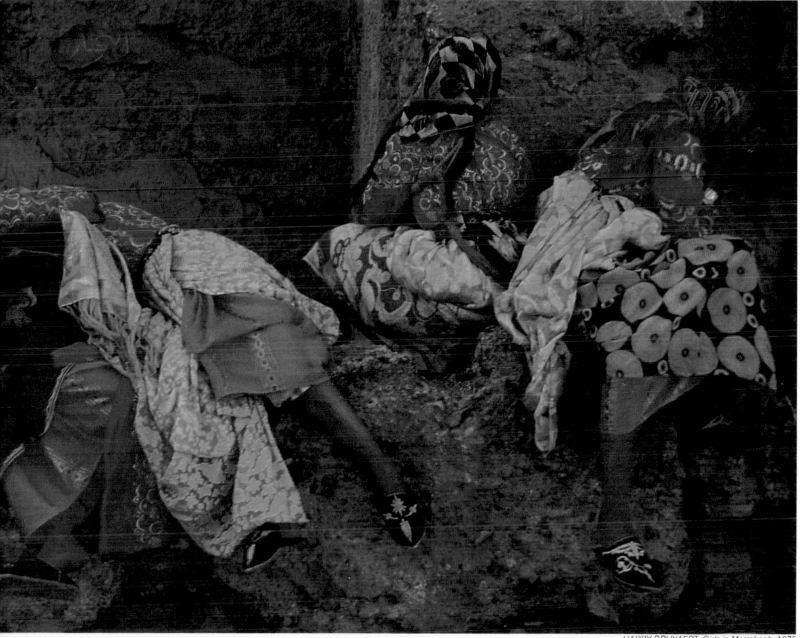

HARRY GRUYAERT: *Girls in Marrakech,* 1975

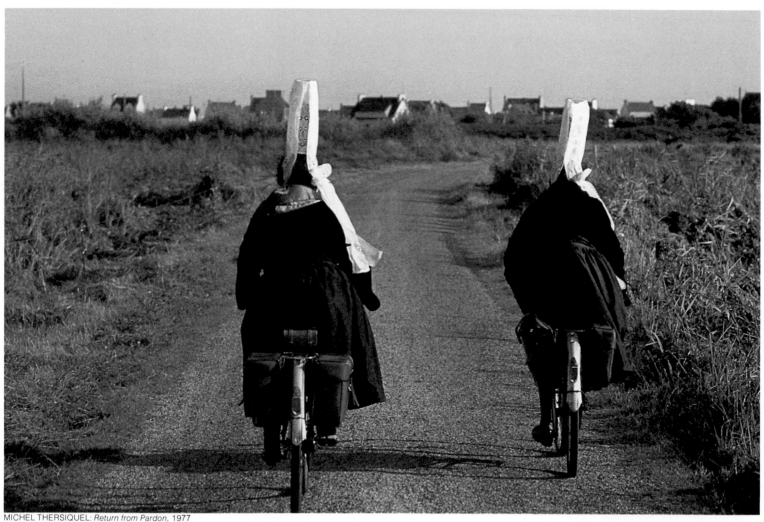

MICHEL THERSIQUEL: *Return from Pardon*, 1977

In Brittany, two Frenchwomen pedal home in
full regalia after a religious ceremony called pardon.
Their distinctive regional headdresses alone
would have merited a picture, but the incongruity of
the elaborately costumed matrons on homely
little bicycles makes this a memorable photograph.

The First Pictures from Afar **2**

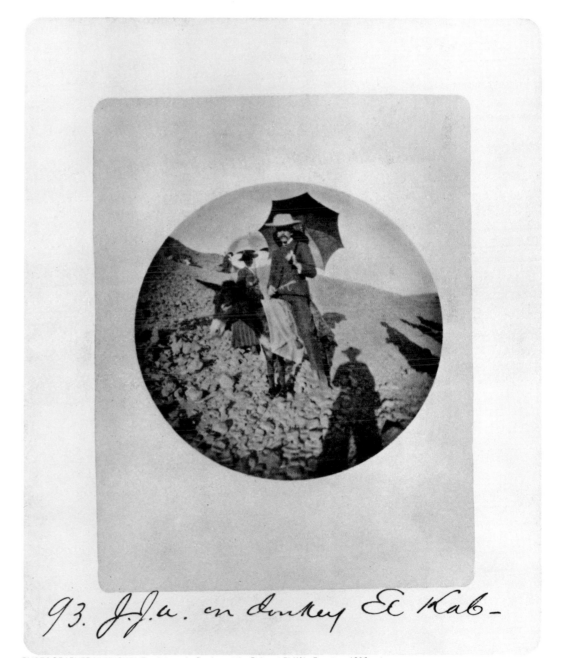

93. J.J.A. on Donkey El Kab —

PHOTOGRAPHER UNKNOWN: *Tourists and a Donkey at the Ruins at El-Kâb, Egypt*, c. 1890

A Planet Fresh from the Camera

In the mid-19th Century, the world was still full of out-of-the-way wonders, but steamships and railroads were making it possible for people to reach more and more of them. And the camera was a magic box that helped those who traveled to preserve and spread their vision— enabling those who did not travel to look at all the far-off marvels without leaving their firesides. The photograph itself was no less a marvel than the wonders it depicted. "Oh, infinite volumes of poems that I treasure in this small library of glass and pasteboard!" exclaimed Oliver Wendell Holmes of his collection of three-dimensional stereographic photographs. With it, he wrote, "I stroll through Rhenish vineyards, I sit under Roman arches, I walk the streets of once-buried cities, I look into the chasms of Alpine glaciers, and on the rush of wasteful cataracts. I pass, in a moment, from the banks of the Charles to the ford of the Jordan."

The travel photographer of the day did more than provide pleasant daydreams for Holmes and other stay-at-homes. He acquainted them with the flora and fauna, the art and architecture of lands that most of them would never see for themselves. He showed them how other peoples lived, worshipped, dressed and fed themselves, amused themselves, married, gave birth and died— some according to customs that already were vanishing forever, like those of the American Indians. In European cities the photographer recorded the crumbling of old landmarks; on the American frontier he recorded the breaking of new soil.

Travel photographs exerted much of their great influence on the public mind through an institution called the illustrated lecture, a slide show (glass slides, in black and white) of pictures of distant places projected in schools, churches and homes. One William H. Rau of Philadelphia advertised that his slides were "made on specially imported thin crystal glass of a superior quality, entirely free from bubbles."

Single slides sold for 50 cents; a set of 60 that took the viewer on a "Tour of the World" could be had for $30, complete "with descriptive reading, packed in grooved box." The tour started out with a view of the interior of Independence Hall in Philadelphia, proceeded west across the United States through Yellowstone, Yosemite and San Francisco, then moved on to China and Japan, through the Middle East and Europe, and ended back in the United States with a view of the Statue of Liberty in New York.

The public illustrated lectures became a lucrative business for educationally oriented showmen, who compiled their own slide collections and talks to go with them. One of the most famous was an engaging youth named Burton Holmes (not related to Oliver Wendell Holmes), who had so much fun with his venture that he called it his "plan for dodging work"; in fact, he worked hard putting together a very good show indeed. For his first performance — given on a fall day in 1893 at 11 a.m. because he could rent the hall for a

bargain price in the morning— he used pictures he had previously taken on a trip to Japan, and wrote and memorized material to go with them. When Holmes's second show began that same evening the house was full to overflowing with Chicago's high society, all in evening dress, and Holmes was launched on a lucrative career that was to make his name a household word.

Most of the early travel slides, like travel pictures of all kinds, were made not by the men who used them but by professional photographers. The pioneers among them were an intrepid breed, each one a man of parts: adventurer, explorer, artist, teacher and bearer of wondrous tales.

He also had to be a craftsman and a technician. No push-button camera holding a lightweight roll of plastic film existed for the early traveling photographer, and no obliging laboratory stood ready to process his pictures for a fee; he had to know how to do everything, from composing and focusing and exposing the picture to sensitizing the plate and developing it. Moreover, until the perfection of the dry-plate process in the 1870s, he had to do all the necessary operations on the spot, because development could not wait. That meant hauling cartloads of equipment weighing up to 120 pounds all the way to the scene: two or three cameras as big as some television sets; as many as 100 glass plates for negatives, some as large as 20 x 24; a variety of lenses and tripods for each of the cameras; a tent to set up as a darkroom; jugs of chemicals and an assortment of incidental gear.

So burdened, the first photographers contented themselves with recording the look of the land— the cool serenity of the Parthenon, the virgin plains and towering mountains beyond the Mississippi. As the land and landmarks became more familiar and as photographic equipment became less cumbersome, photographers looked more closely at the people they encountered in their travels: Visions of human beings smoking opium in Persia, having their toenails cut in China or dancing in a plea for rain in the Arizona Territory were no less astonishing than views of ancient monuments.

Toward the close of the 19th Century, travel pictures began to change as advances in transportation attracted a whole new class of travelers and an indefatigable inventor named George Eastman devised a mass-produced roll-film camera (page 62), fathering a whole new breed of photographer. The new travelers, touring farther and farther afield with their easy-to-use cameras, began not only to snap spectacular landscapes and exotic people, but to record their own presence— to photograph and to be photographed in faraway places, making pictures to show and tell about when they got home. An art that previously had been limited to a hardy and well-heeled elite now was ready to pass into the hands of anyone with imagination and a few dollars to spare. Travel pictures became more casual and more spontaneous — each individual's own interpretation of what he saw. □

Documenting the Wonders of the World

Nowadays, when a flight from Paris to Athens takes a couple of hours, and the steps of a journey on the moon's surface can be followed minute by minute on TV, it is difficult to re-create either the wonder or the apprehension inspired by travel hardly a century ago.

In 1849, when the future novelist Gustave Flaubert took leave of his mother to accompany photographer Maxime Du Camp *(page 46)* on a picture-taking expedition to the Middle East, the event caused a family crisis. "What a cry she uttered when I shut the door of the living room," Flaubert wrote. "It reminded me of the one I heard her make when my father died." The young man was hardly more composed himself, and Du Camp found him later the same evening prostrate before the fireplace, sobbing: "I'll never see my homeland again."

Not all travelers were as fearful as Madame Flaubert and her son, but there was reason for misgiving. Few foreign sites were as serene as the Acropolis *(right),* and photographers who ventured on tour to bring stay-at-homes their first clear views of strange lands and even stranger people found rigors aplenty.

John Thomson, an unexcitable Briton who traveled with his camera to China, wrote of "placing my revolver beneath my pillow, and the matches close to the candle." Timothy H. O'Sullivan, who photographed much of the American frontier, wrote of the "unlimited number of the most voracious and particularly poisonous mosquitoes" he encountered, not to ignore "that most enervating of all fevers, known as the 'mountain ail.'" Charles R. Savage, another photographer of the American West, noted that every campsite had to post guards "to keep a sharp lookout for any sneaking red-skins."

Other photographers discovered ways to make friends with the strange people they met, though winning them over took an elastic turn of mind. Edward S. Curtis, who photographed the Hopi maidens on page 57, had to learn and abide by Indian customs before he was made privy to their secret rituals. "I fasted with the Hopis," he wrote, "wore the costume of a priest, painted my body in the sacred manner and slept in the kiva beside a native priest who was my informant and interpreter. Since I was a novitiate, the snakes were placed around my neck before going into the bags."

Not that snakes and deserts, glaciers and primitive peoples appeared on every 19th Century travel photographer's itinerary; some faced hazards no worse than the gondola traffic in Venice or the street traffic in Paris, both slow moving. But by the time these far-ranging recorders of the exotic were finished, the world was no longer quite the mystery it had been; some of its grandest sights were on the way to becoming clichés.

With the almost unreal sharpness of detail that Renaissance landscape painters had favored, a 19th Century traveling photographer recorded the ruined majesty of the Acropolis, half a mile distant from his camera, in the brilliance of the Greek sunshine. Another camera, its focusing hood draped over it, is set up to capture the same stunning scene from a different point of view.

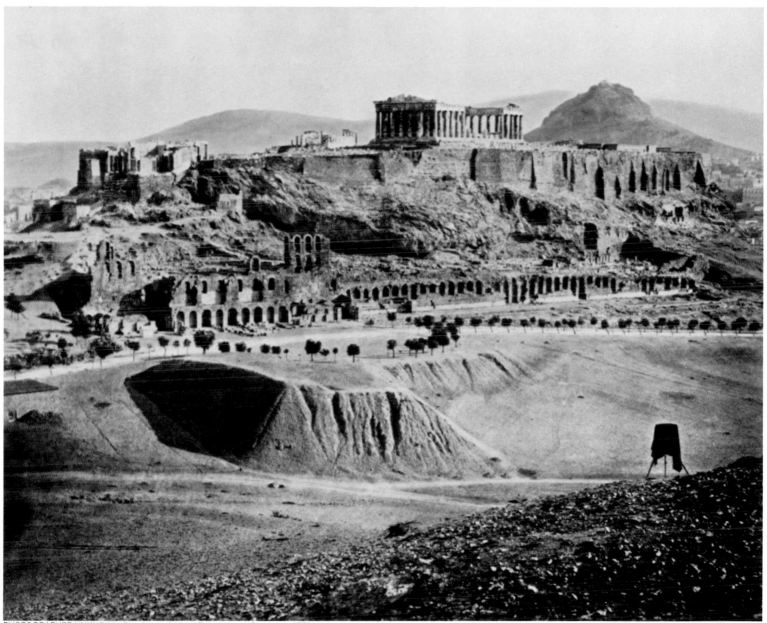

PHOTOGRAPHER UNKNOWN: *The Acropolis from Philopappos, Greece,* c. 1870

Venice, with its network of romantic canals and its suggestion of Oriental exotica, had great appeal for Victorian travelers and stay-at-homes alike. In this picture Stieglitz, who had gone to Germany to study engineering and instead took up photography, summarized the fabled city in a vignette of dappled water and crumbling masonry.

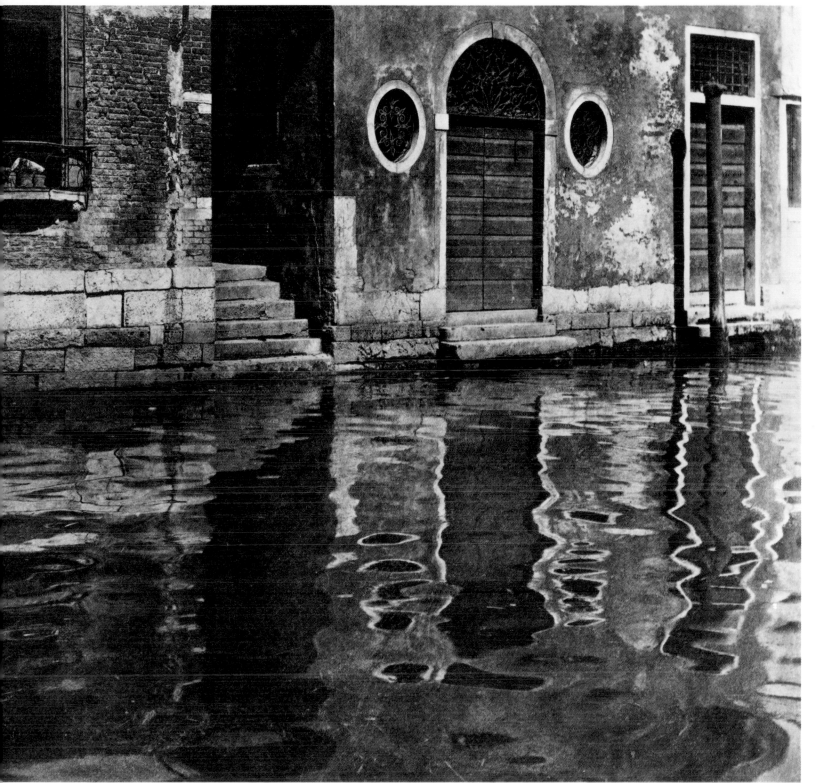

ALFRED STIEGLITZ: *Venice,* 1897

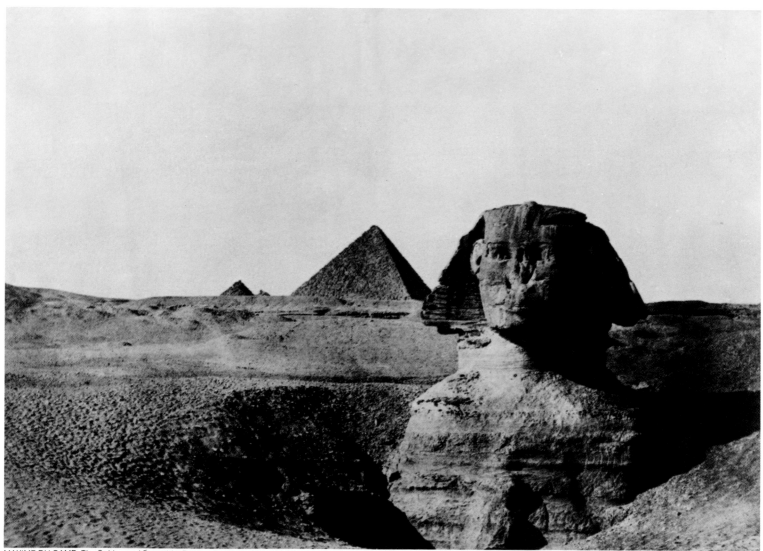

MAXIME DU CAMP: *The Sphinx and Pyramids, Egypt,* 1851

*The face of the Great Sphinx at Giza, which few
people had then seen, looms up ahead of a row of
pyramids in one of 125 pictures made for the
French Ministry of Education and published in one of
the first books to be illustrated with photographs.*

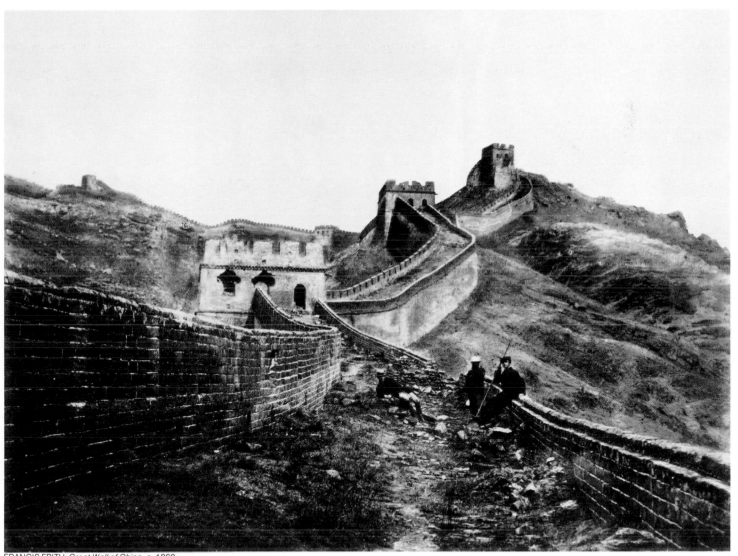

FRANCIS FRITH: *Great Wall of China*, c. 1860

In a faraway land that, in the 19th Century, drew
traders and missionaries before it attracted
tourists and archeologists, a British photographer
demonstrates the vast scale of the Great Wall of
China by placing three companions in his picture.

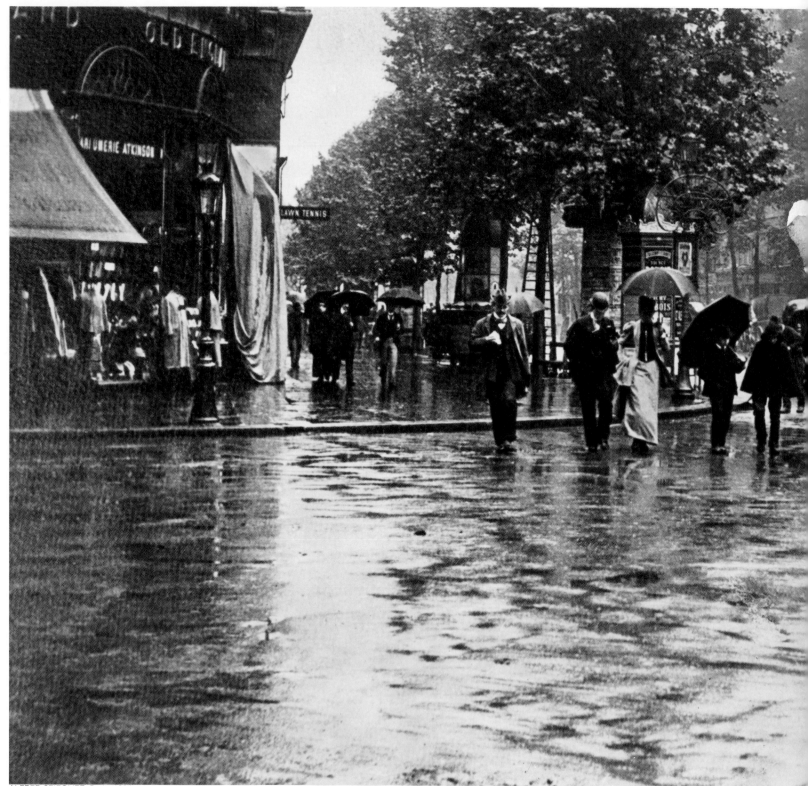

ALFRED STIEGLITZ: *Paris,* 1894
48

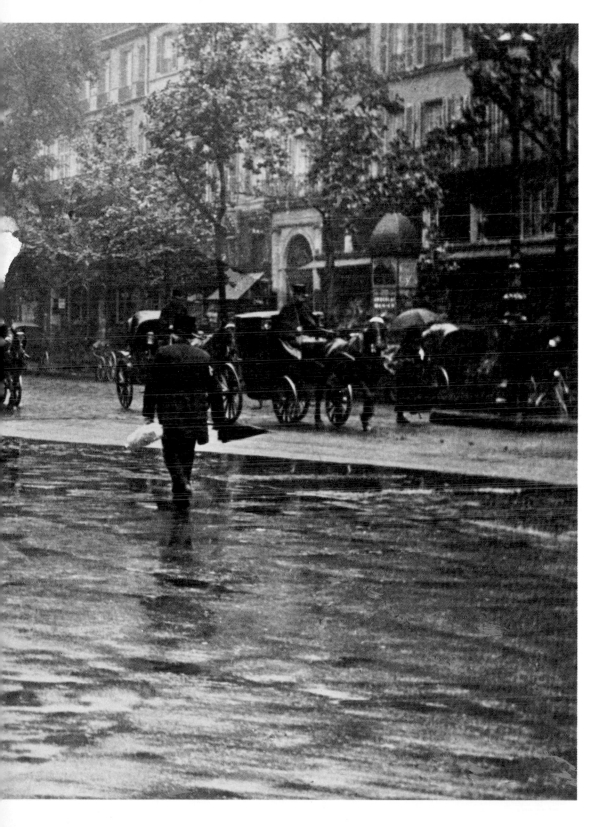

At the junction of Boulevard des Capucines and
Rue Scribe—the Old England store stands
on the corner at left—Paris goes about its business
heedless of the photographer, the pedestrians
and horse-drawn carriages moving along
the glistening street on a rainy day in 1894. This
deceptively casual approach, showing the
everyday appearance of a seemingly exotic city,
was revolutionary in the 1890s, when most
travel photographs focused on the monumental.

A year before Yellowstone was set aside as federal property — and long before any but explorers had set eyes on it — photographer William Henry Jackson made the first pictures taken in that Wyoming wilderness. The picture at right shows Thomas Moran, official painter to the expedition, surrounded by volcanic rock and pools of boiling water. It was such stunning photographs by Jackson that persuaded a dubious Congress to designate the 3,578-square-mile tract a national park, the first in the world.

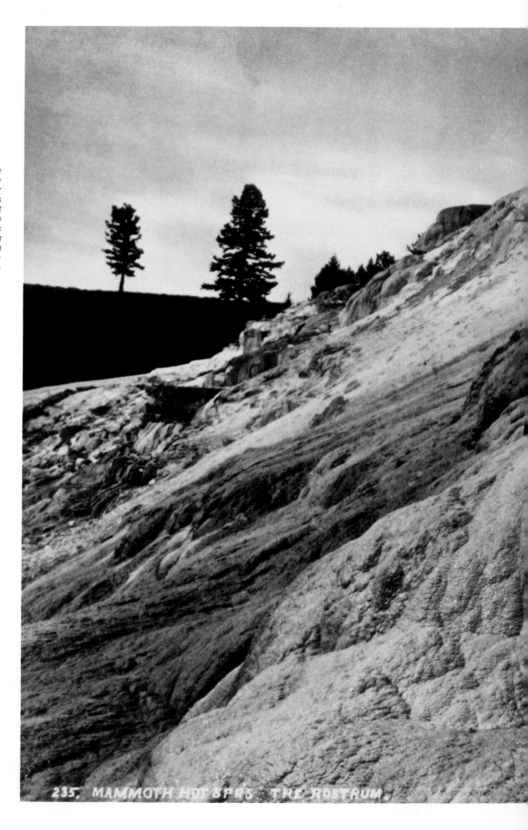

235. MAMMOTH HOT SPRS. THE ROSTRUM.

WILLIAM HENRY JACKSON: *Mammoth Hot Springs, Yellowstone Park*, 1871

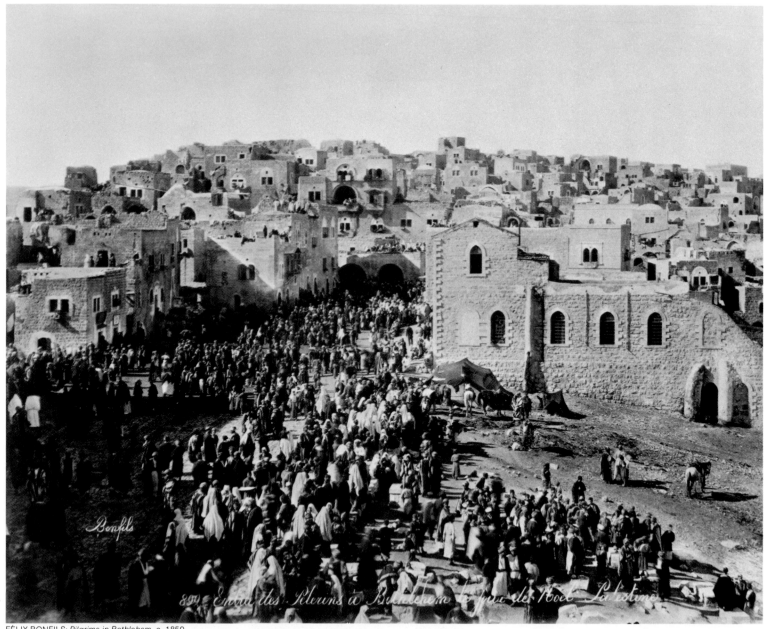

FÉLIX BONFILS: *Pilgrims in Bethlehem*, c. 1850

◀ *A French photographer caught thousands of pilgrims milling about a hill in Bethlehem on Christmas Day, fulfilling their dreams of commemorating the nativity of Christ in the place of His birth. Until about the time the picture was made, this dream of devout Western Europeans had been realized only by the most adventurous. But the development of the steamship in the middle of the 19th Century greatly simplified travel to the Middle East, where religious feeling and wanderlust attracted many to the Holy Land.*

The Holy Land also drew travelers with scholarly interest in its historical background. At right a German photographer documented the Church of the Holy Sepulcher in Jerusalem, traditional site of Christ's entombment, catching in this small close-up the spare lines of the architecture, the parched stones that bespeak centuries of baking in the sun, and the poignant presence of a human pilgrim suggested by the abandoned basket lying in front of the sealed doorway

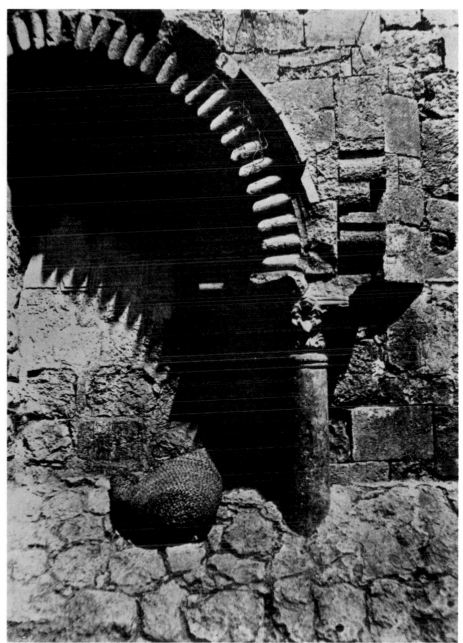

AUGUSTE SALZMANN: *The Holy Sepulcher, Jerusalem, 1856*

Climbing Mont Blanc in the French Alps is still a
big adventure; the ascent in the 1860s, laden with
photographic gear, was something new and
all but incredible. Yet Louis Auguste Bisson, who
had studied under Daguerre, and Louis' brother
Auguste Rosalie did just that on an expedition
commissioned by Emperor Napoleon III. One
member of the team got this view of the heavily
laden climbers inching their way up the mountain.
At 16,000 feet the below-zero temperatures
nearly froze the wet-collodion emulsion, which had
to be applied to the plates just before use.

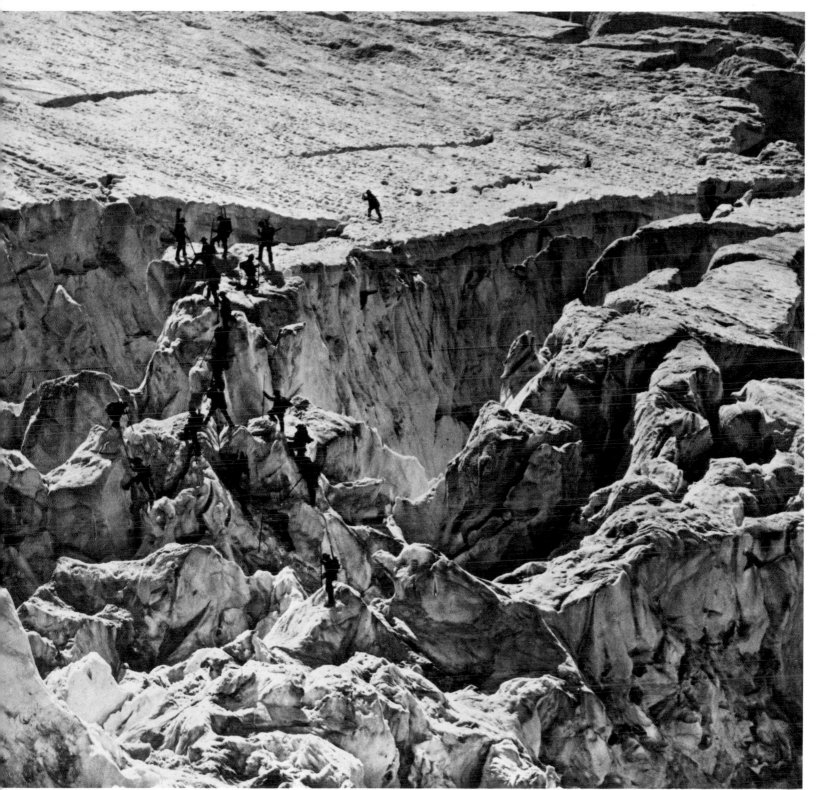

BISSON FRÈRES: *Mont Blanc*, 1860

Focusing on the Human Race

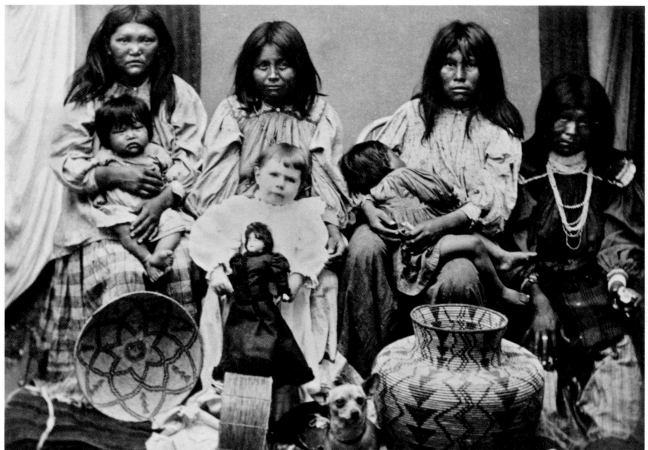

ARTHUR FELDMAN: *Apache Squaws and Babies, Arizona,* c. 1890

By the 1860s, travel photographers had expanded their interests from architecture and landscapes and had begun to concentrate on the people they found. Increasingly sophisticated camera equipment made it possible to record subjects that breathed and shifted about—and were ultimately *(Chapter 6)* to become a major part of travel photography.

For Europeans this new approach usually meant photographing Asians and Africans in their native environments; for Americans it usually meant documenting the Indians of the West, who sometimes seemed to be more alien and exotic than any other people on earth. Some observers found them simply objects of curiosity; a few were farsighted and sensitive enough to perceive that the Indians' fading culture should be captured in pictures before it disappeared altogether.

Two photographers possessed of such perspicacity were Arthur Feldman and Edward S. Curtis, who made the pictures on these pages. These two men gave Easterners a measure of insight into the pride and dignity of their strange Western countrymen, who until then had most frequently been portrayed only as stereotypes of savagery.

◀ *Some Apache mothers and their babies sit for a traveling photographer with a white child mysteriously present — probably a member of a family working among the Indians. Except for the factory-made doll in the outsider's lap, the artifacts — the bowl and basket, the long skirts and loose-fitting blouses — show the beauty and craftsmanship of Apache culture.*

Four Hopi girls gather on a pueblo terrace in Walpi Village, their centuries-old dwelling place, composing themselves in a timeless travel picture. Their hairdos, coiled to resemble squash blossoms, are an indication that they are marriageable.

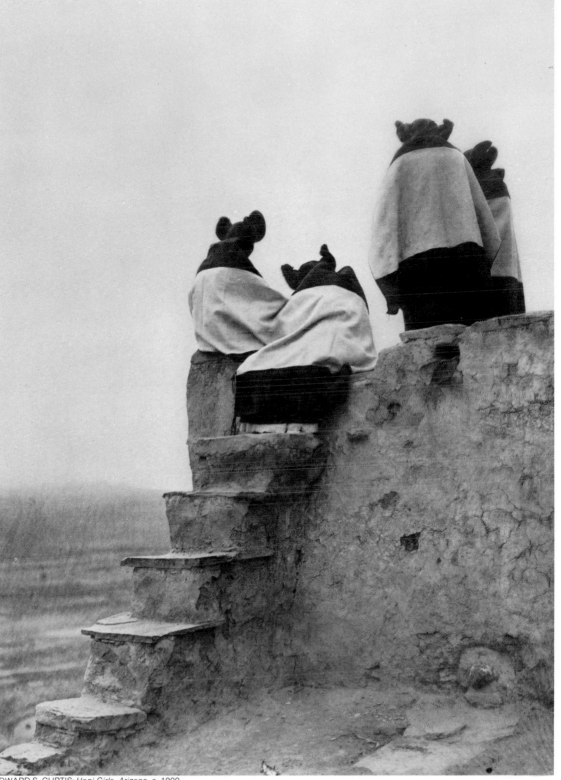

EDWARD S. CURTIS: *Hopi Girls, Arizona,* c. 1900

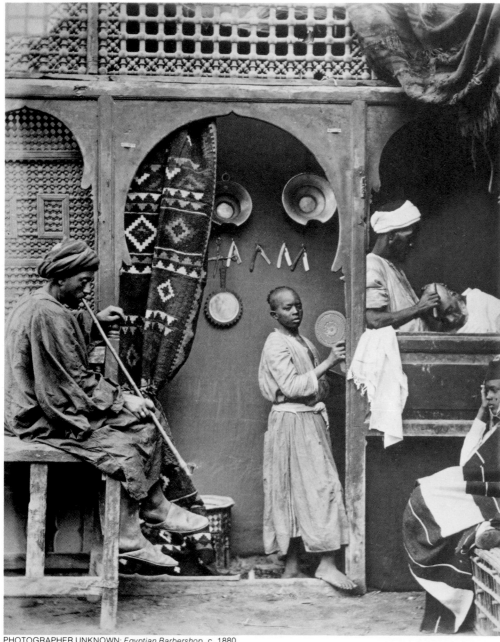

PHOTOGRAPHER UNKNOWN: *Egyptian Barbershop,* c. 1880

At an open-air barbershop, four Egyptians made up a scene that, to 19th Century European viewers, seemed a candid glimpse of the exotic Orient. Inside the arcade under the intricately carved mushrabiya (wooden latticework), a customer reclines to have his head shaved while a boy stands behind with a fan to cool him; outside, a man (possibly waiting his turn) smokes a yard-long pipe and another boy sits in silent meditation.

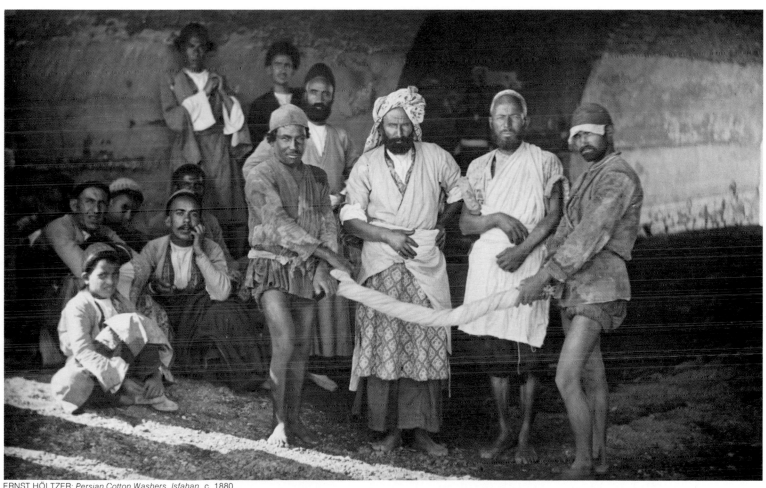

ERNST HÖLTZER: *Persian Cotton Washers, Isfahan,* c. 1880

The picture of Persian textile craftsmen above,
like many of the best of the early travel
photographs, was made by a man engaged
primarily in nonphotographic work. It was
taken by a German engineer who, while
constructing the first telegraph line across
the country, gathered a priceless store of
photographs documenting Persian society
of the day. This one shows a group of cotton
washers demonstrating one of the many
steps needed to produce cotton prints. The
cotton washers, well paid and middle class,
had one of the largest guilds in Persia.

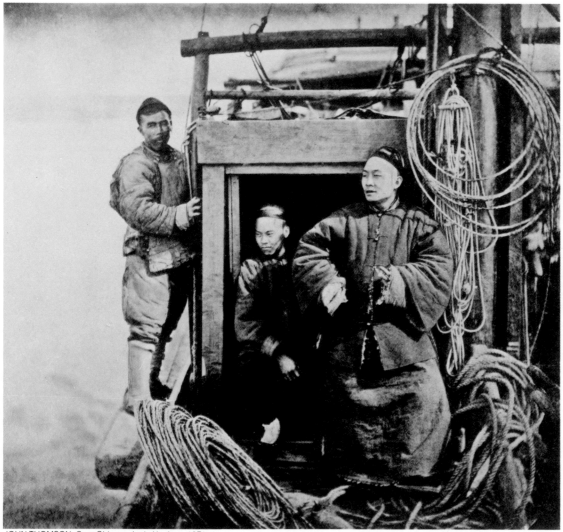

JOHN THOMSON: *On a Chinese Junk, Hankow,* 1871

*With a lordly mien that shows his importance,
the photographer's Chinese interpreter takes an
imperial stance in front of the cook and an
attendant on the Yangtze riverboat that carried
them from Hankow. Not every Chinese modeled
so cheerfully. "The superstitious influences,"
Thomson wrote, "rendered me a frequent object
of mistrust, and led to my being stoned and
roughly handled on more occasions than one."*

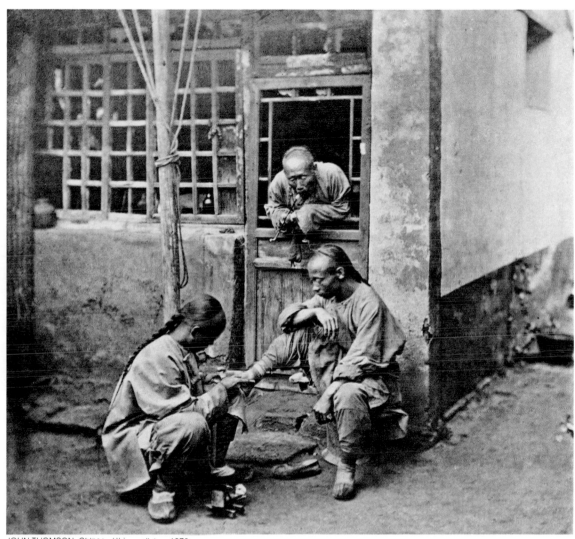

JOHN THOMSON: *Chinese Chiropodist,* c. 1870

*A traveling chiropodist from Peking removes a
corn and pares the toenails of a client somewhere
in rural China as another customer waits his turn.
Pictures like these, which were meant to convey
"the arts, usages and manners which prevail
in different parts of the Empire," were Thomson's
goal, sure to please the curious back home.*

The Tourist Gets into the Scene

For about half a century, travelers who practiced photography were for the most part professionals; the rest were amateurs who devoted so much time and expense to its techniques, and acquired so much skill, that they qualified as semipros. The subjects that were preferred by both in far-off places were the strangest they could find—at first strange-looking landscapes and architecture, and then strange-looking people engaged in what seemed to be strange occupations.

Later in the 19th Century, the photographers changed and their subjects did, too. Thanks to freer-flowing money and easier travel, tourists increased in number and traveled ever farther—and when they got where they were going, they became the camera's targets.

As equipment became faster and less obtrusive, pictures became more candid and the subjects loosened up—often to the point of being unaware they were being photographed at all *(page 69)*. More typically, travelers asked that their pictures be taken, to show to friends at home and to remind themselves of what they had seen and done.

A professional photographer was as likely as not to be on the spot to oblige. Often he was the local entrepreneur who stood ready to record the eager visitors clambering up the sides of pyramids, lolling in frilly litters borne by porters, or mugging in a row before ancient pillars. He posted himself at the site, importuned the tourists as they arrived, and then sold them their pictures for a nominal fee.

But the biggest change in travel photography occurred when George Eastman *(opposite)* invented the Kodak box camera, a gadget so easy to use that anyone could work it. Now tourists could do the picture taking themselves. "You press the button; we do the rest," said Eastman in advertising his brain child, and he meant it. He even thought to include a notebook with each roll of film, so the photographer could identify his pictures when he got them back.

People who traveled switched promptly to recording their experiences on film instead of in journals. One tourist took a Kodak with him on an around-the-world bicycle trip; on one of Lieutenant Robert E. Peary's expeditions in search of the North Pole in 1898, a Kodak went along on a dog sled to document the event. Travelers with cameras still had to keep their wits about them, however; President Grover Cleveland was said to have spent all day on a fishing trip taking pictures, only to find that he had forgotten to wind the film between exposures.

Fortunately, most of the old-time traveling photographers were not that absentminded. They left a legacy of pictures that are charming, interesting and irreplaceable as a record of a world now largely lost. Some of them were taken by professionals with sophisticated equipment; some were taken by the new legion of amateurs with Eastman's handy Kodak; but all show the new dimension that photography added to travel.

George Eastman, who put the Kodak box camera on the market and thereby put photography into everybody's hands, stands aboard the S.S. Gallia in the act of working his new invention. The picture was taken by a friend of Eastman's with another of the recently introduced No. 2 Kodaks.

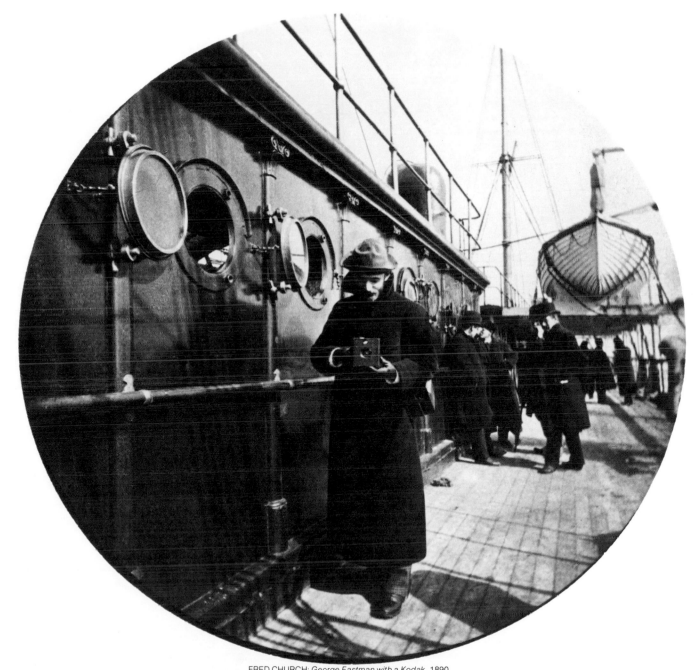

FRED CHURCH: *George Eastman with a Kodak*, 1890

For a good many years before George Eastman sent tourists on their way with handy cameras they could use for making snapshots of their own *(preceding pages),* earlier entrepreneurs had been supplying them with another kind of photographic reminder of the trips they made away from home. That was the stereograph image, a pair of pictures (almost but not exactly alike) that, when looked at through a stereoscope, appeared to be three dimensional.

These photographs, which were introduced about 1840, became in time the Victorian equivalent of the color slides that are sold at souvenir stands the world over today. They could be bought for a few cents, either on the scene or at an emporium back home.

The view might be a photograph of anything anywhere, but for a long time the most popular subjects were the sites that were luring vacationing travelers— places that were historic like the Acropolis *(near right, above),* exotic like Tangier *(far right, above),* or adventurous like the Matterhorn and Yosemite *(bottom).*

Many views, like these, had tourists in them, suggesting to the purchaser that in just such scenes he might find himself. On the backs of some were short lessons with such information as: "Mountain climbing is an interesting sport, even though it is dangerous. Most of the tall peaks of the world have been climbed by hardy men. Each year there is a death toll, due to carelessness or accident; but this does not cause the sport to cease."

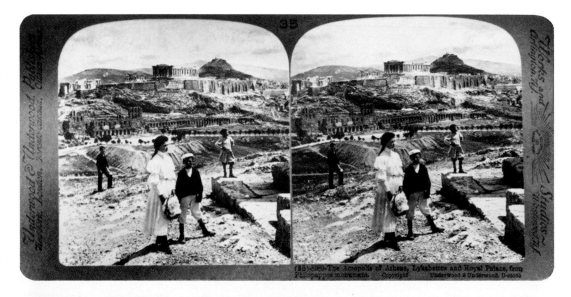

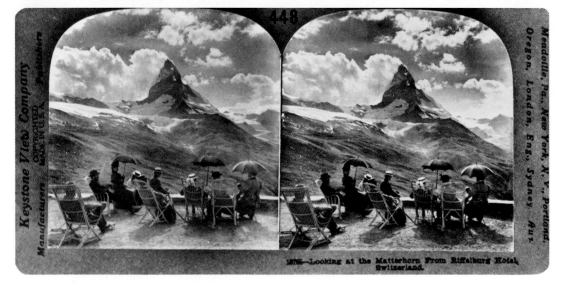

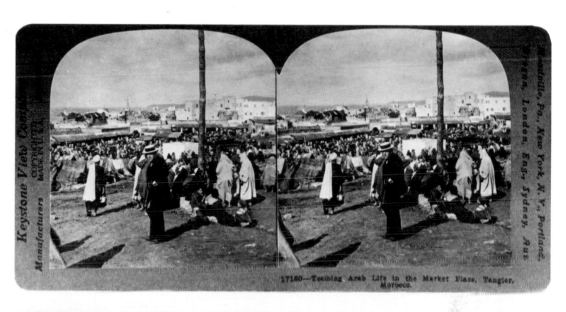

Keystone View Company
Manufacturers
COPYRIGHT
MADE IN U.S.A.

...dsville, Pa. New York, N. Y., Portland
Oregon, London, Eng., Sydney, Aus.

17150—Teeming Arab Life in the Market Place, Tangier, Morocco.

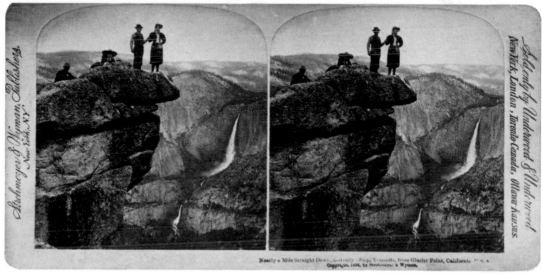

Strohmeyer & Wyman, Publishers.
New York, N.Y.

Sold only by Underwood & Underwood
New York, London, Toronto-Canada, Ottawa-Kansas

Nearly a Mile Straight Down, and only "Step, Yosemite, from Glacier Point, California
Copyright, 1901, by Strohmeyer & Wyman.

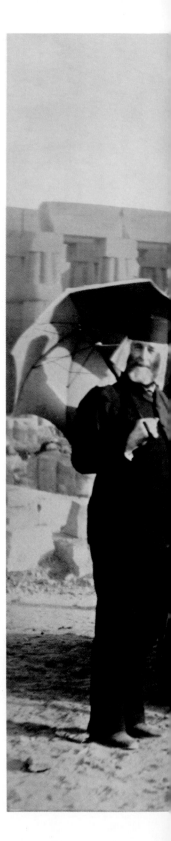

Equally informal, but more likely to have been recorded by a professional photographer using a large view camera, a group of tourists —one of them astride a camel and several carrying parasols against the blazing sun —gather outside the court of Amenhotep III at the Temple of Luxor.

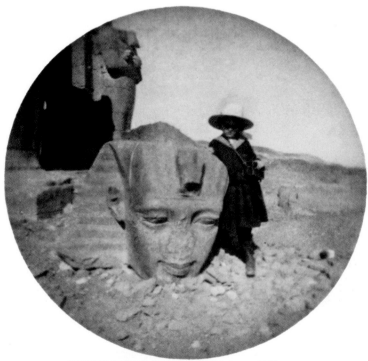

PHOTOGRAPHER UNKNOWN: *Ruth at Thebes*, c. 1890

Striking a demure pose that was to be repeated in countless tourist snapshots, a camera-carrying girl traveling in Egypt arranged herself by the stone head of Ramses II, while a companion immortalized the scene on the round frame that marks it as an early Kodak picture. The photographer is unknown, but the handwritten note in the album from which this picture came indicates that the girl's name was Ruth.

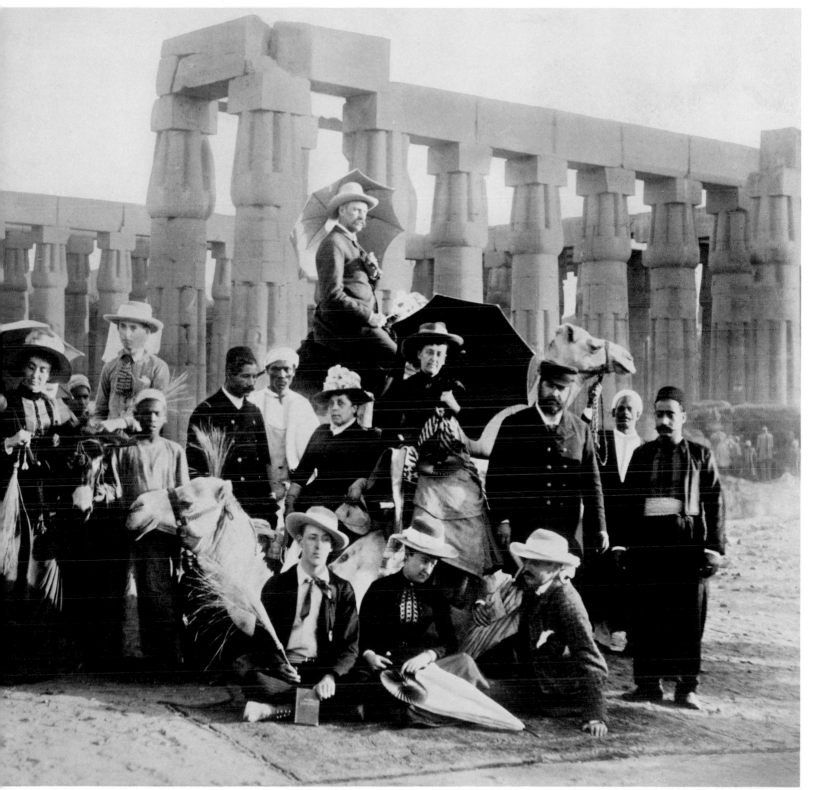

PHOTOGRAPHER UNKNOWN: *The Nile Party*, c. 1890

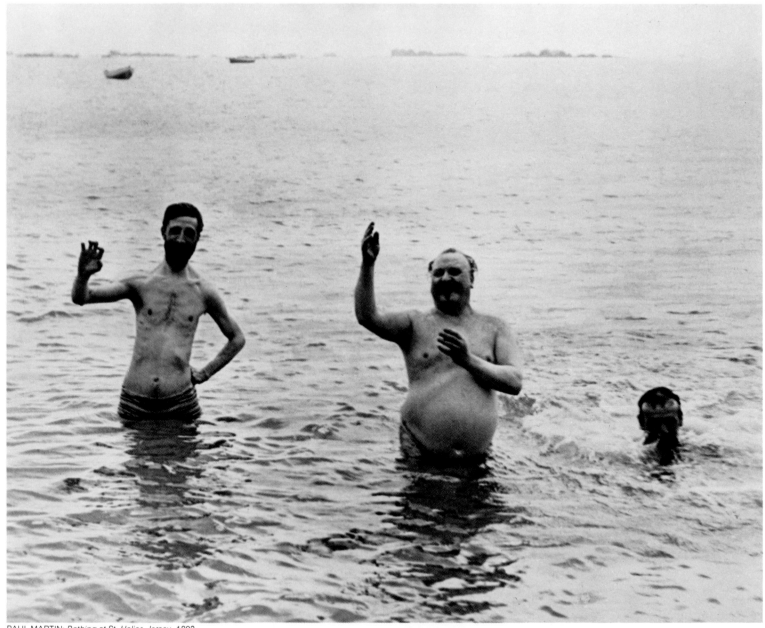

PAUL MARTIN: *Bathing at St. Helier, Jersey*, 1893

Three jolly Englishmen on holiday by the sea send some cheerful waves in the photographer's direction. Paul Martin was a pioneer of informal pictures, taking full advantage of a newly developed small and unobtrusive type of camera that had a built-in plate-changing device for making several shots in rapid sequence. Through his camera, he wrote, "I discovered the joy of reacting spontaneously to real life. . . ."

A well-dressed couple, happily cuddling in the sand far from home, remain apparently as oblivious to the photographer as they are to the vacationers in the background. The sneaked picture was made possible by Martin's inventiveness. When he was not traveling in search of candid scenes he tinkered with his camera, and one of his inventions was a silencer that reduced the startling clunk of the plate-changing mechanism to an unobtrusive click.

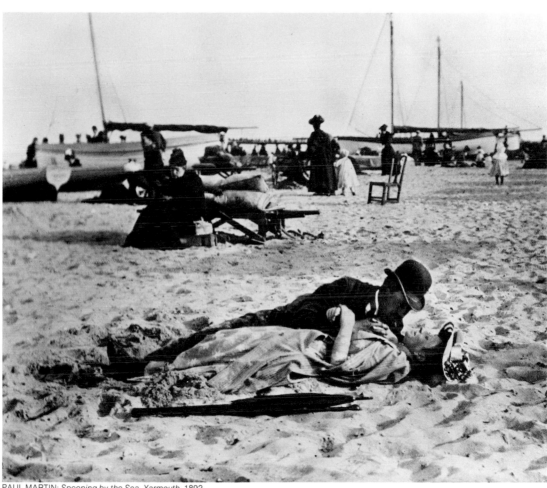

PAUL MARTIN: *Spooning by the Sea, Yarmouth,* 1892

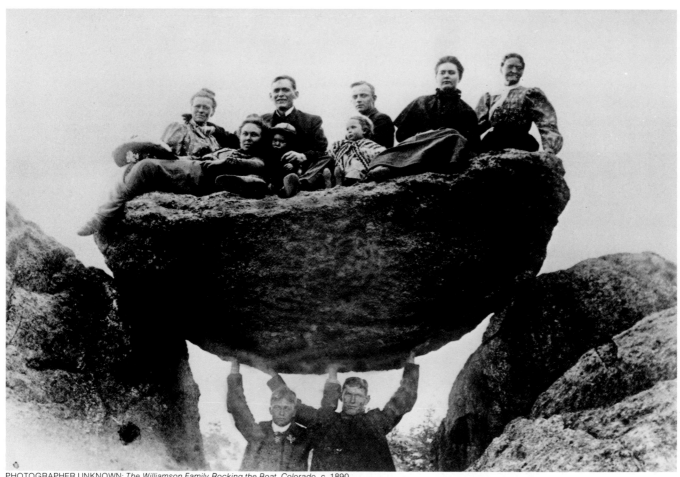

PHOTOGRAPHER UNKNOWN: *The Williamson Family Rocking the Boat, Colorado,* c. 1890

Gimmick shots had great appeal in the Gay Nineties, when life was carefree and the camera was the traveler's new toy. Here a traveling family has some sport with a strange geological formation, called the Boat Rock, that they found near Turret, Colorado — now a ghost town.

For all the fun and games to be had on tour, travel ▶ also required stamina and sturdy legs. These tourists proved it for the folks at home by getting the photographer to record them clambering up a corner of the Great Pyramid at Giza.

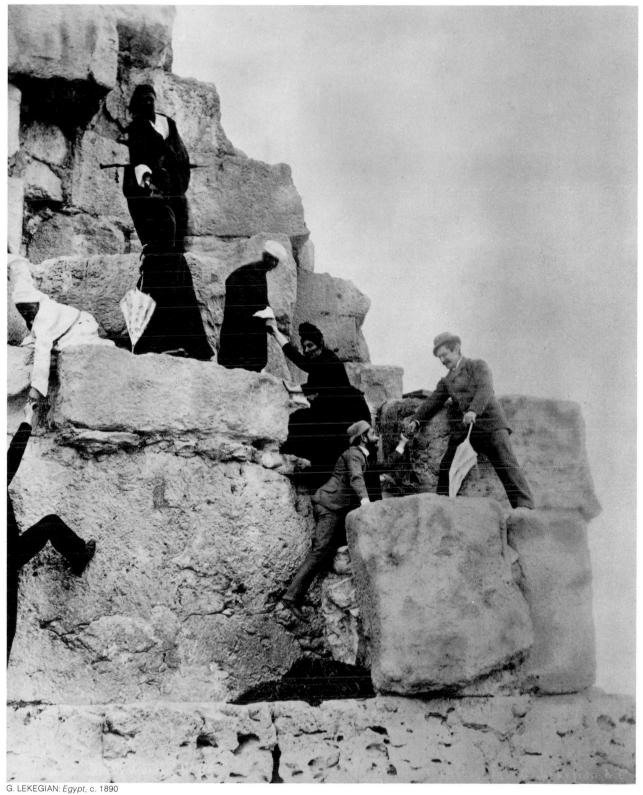

G. LEKEGIAN: *Egypt*, c. 1890

Even where the going seemed rough, a camera was at hand to record a well-heeled tourist like this one, a British gentleman traveling the easy way through the mountains of Madeira. While his companion looks on, he reclines in a litter borne by two porters wearing the white uniforms and straw hats that mark their occupation.

PHOTOGRAPHER UNKNOWN: *Madeiran Wayside*, c. 1885

73

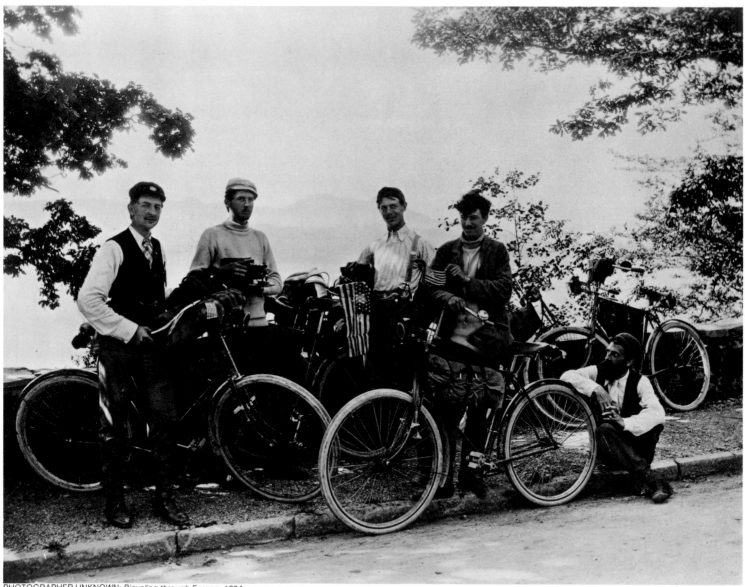

PHOTOGRAPHER UNKNOWN: *Bicycling through Europe,* 1894

*Travelers quickly took up the newly popular
bicycle in the late 19th Century, and these hardy
cyclists paused for a snapshot in Europe, their
flags showing they are Americans far from home.*

The Well-Planned Trip **3**

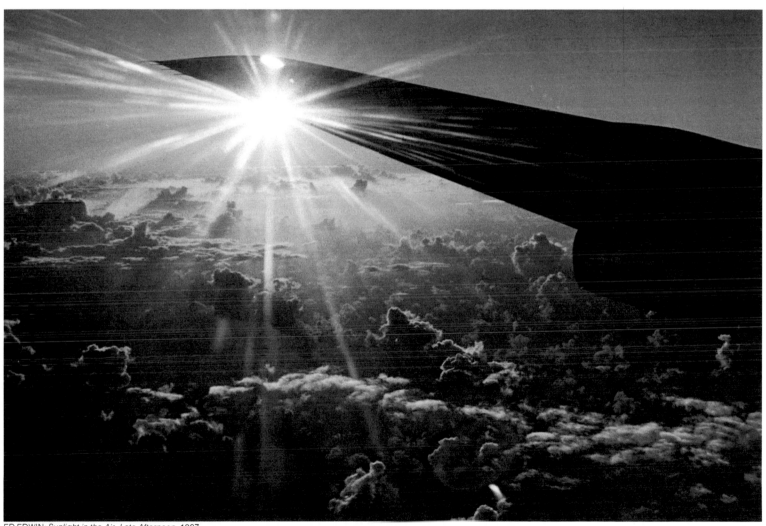

ED EDWIN: *Sunlight in the Air, Late Afternoon, 1907*

What to Take Along

The traveler who photographs has a double packing job to do. Once the choice of clothing, shoes and toilet articles is dealt with, he turns to assembling his photographic gear. This is a more exacting task: it involves planning a kit that is light enough to be carried by hand, sturdy enough to withstand the jolts of transportation and varied enough to deal with nearly any picture that may present itself. The photographer does not want to be burdened with equipment he will never use, but he does want to be prepared for the unexpected picture and to be able to do it justice. What does he take along, and what does he decide to leave behind? Individual requirements necessarily vary, but a suggested set of useful equipment is shown on page 81 along with a sturdy shock-proof carrying case.

There is mental packing to do, too. For the traveler should learn the regulations and customs of countries on the itinerary—nations, like people, have their idiosyncrasies. Many impose no official limits on the equipment that can be taken into them; others have rigid restrictions. All have some rules about what can be photographed within their countries. French customs officials admit tripods; does the Louvre do the same? Yes, for a small fee. The government of Spain puts no specific limit on photographic equipment allowed into the country, but can the equipment be taken inside Madrid's famous museum, the Prado? No, not even a camera. On the other hand, in many churches and cathedrals there are no restrictions except the obvious one of common courtesy; the photographer's opportunities, as Dmitri Kessel shows on pages 96-104, are vast. The restrictions a photographer may expect to encounter in other lands and in museums are detailed on pages 86-89.

Once the photographer has learned what he will be allowed and has decided what he will need in the way of cameras, lenses and other appurtenances, he faces another decision: should he take it all along when he leaves home or get some of it en route? The answer is simple: with the single exeption of film, it is not a good idea to pick up basic photographic equipment abroad for use on the trip. One good reason is that United States Customs allows the traveler to bring only $300 worth of duty-free goods back into the country. Anything valued at more than that amount is subject to customs duty; and that can substantially raise the price of a bargain lens.

More important than saving money is saving time; travel days are too precious to spend practicing with unfamiliar gear. All equipment should have a thorough trial run to be sure it works, and to make its use as familiar as winding a wristwatch. Many pictures call for all the manual dexterity the photographer can command, and that requires familiarity with the equipment. Also, if anything is out of order it should be discovered in advance.

How much film the traveler needs depends on his photographic intentions; most serious amateurs average about three rolls for each day of travel. Film is

the one thing that can easily be found and safely purchased in every major city. It often costs more abroad than it does in the United States, but it may be necessary to buy it there because some countries have regulations that limit the amount of film that can be brought in.

In any country the photographer may suddenly find that he does not have the right film in his camera for a chosen subject. He need not give up on the picture: even if he has nothing but a roll of medium-speed daylight film with him he can still get that shot of a museum interior. The trick is to "push" the film— that is, set the exposure as if the film were two or even four times more sensitive than its normal ISO rating (the effect is underexposure by one or two f-stops); then instruct a custom-processing laboratory to compensate for the underexposure by prolonging the duration of the development period. For example: using a daylight transparency film with an ISO rating of 200/24° in a dark interior, set the exposure meter for ISO 400/27° or 800/30°. Then adjust f-stop and shutter speed as the meter indicates (it will now register as if the camera contained ISO 400/27° or 800/30° film). Expose the entire roll in this way; do not switch the ISO rating in mid-roll. Mark instructions on the roll (on adhesive or masking tape) when it is removed. "P1" or "P2" is useful shorthand that the processing technician will understand; it means that he is to push one or two stops in developing. A custom developer (not the corner drugstore) will treat the film accordingly— for a slight additional charge— and the probability of success is very good.

Whatever a photographer takes in the way of gear, he should be sure to carry it personally and not check it with his luggage. (An exception: a tripod that telescopes handily will fit in any good-sized suitcase.) One reason for carrying everything is to cut down the risks of theft and damage en route. But more important, a camera in a suitcase cannot be used, and subject matter is to be found on every step of a journey. Mary Leatherbee caught the image of snow reflections on the wing of an airliner in Alaska because her camera was beside her and loaded when she noticed the phenomenon *(page 93)*. All sorts of scenes can be shot when traveling by automobile, often without even getting out of the car; Victor Landweber imaginatively framed an Arizona sunset in his windshield *(page 92)*. With the camera handy and the traveler's eye open, anyone can do the same, from the moment he shuts the front door behind him and starts his travels to the moment he gets back home. □

Keeping the Load Light but Complete

Choosing photographic equipment for a trip means striking a delicate balance: too much and mobility is hampered; too little and the picture of a lifetime may be missed. The kit at right offers the traveler a great deal of flexibility, yet the equipment in it weighs less than seven pounds (just over 12 pounds when the gear is packed in an aluminum traveling case).

The heart of the kit is a 35mm single-lens reflex camera with a normal 50mm lens (1). Light and compact, with handy through-the-lens focusing and metering, an SLR is a practical choice. Ideally it should offer both automatic and manual exposure—automatic for quick shooting under normal lighting conditions, manual for manipulating exposure under tricky lighting or to achieve special effects.

This basic camera is backed up with a second camera body (2) and two extra lenses—a 135mm long lens (3) and a 28mm wide-angle lens (shown mounted on the second body). The extra body is useful not only as a backup in case of a breakdown but also as a container for carrying a different type of film for quick switching from dim interiors to bright outdoor scenes, or from color to black and white. It should take the same lenses and accessories as the main body. Carry spare batteries for each camera.

Instead of taking along normal, long, and wide-angle lenses, some photographers may wish to use a zoom lens that will cover some of the same range. The compactness and versatility of a zoom make it a handy travel tool, but the photographer should keep in mind that the maximum apertures of zoom lenses are generally smaller than those of conventional lenses, so a zoom may be of little use in low light.

A compact, lightweight autowinder (4) can advance the film as quickly as 3½ frames a second—useful for capturing fast action, or just to be sure of freezing a fleeting facial expression. For nighttime and interior shots, a moderately powerful electronic flash (5) is essential. An automatic flash unit eliminates the necessity for calculating exposures; a tiltable flash head makes it possible for the photographer to bounce light off a ceiling or wall for soft, even illumination. Carry spare batteries for both autowinder and flash; if they recharge from house current, an adapter may be needed *(page 89)*.

A hand-held meter that reads both incident and reflected light (13) is useful for time exposures that are beyond the range of the built-in camera meter, or for situations when the built-in meter might be misleading—gauging exposure for a scene across a sunlit river, for example. Take at least one spare battery for it.

Many a tripod that is light enough to carry with ease may prove too flimsy to stand steadily. A well-made tabletop tripod (14) may be a better choice; it can be placed on a car fender or a church pillar *(page 84)*. A ball-joint head sets the camera at any angle on the tripod.

A few smaller items complete the kit. An ultraviolet, or haze, filter (7) protects the lens while absorbing UV wavelengths that can alter the colors in a scene. A transparent film case (8) facilitates both customs inspections and airport security checks. Lens tissue (10) and cleaning fluid (11) will safely remove dust from lenses, and a plastic rain cover (12) will protect the camera in wet weather.

The watertight and foam-lined aluminum case (15) shields gear from foul weather and inadvertent bumps. A case measuring 18 inches by 13 inches will hold all this equipment except the tripod.

1 **35mm SLR camera with 50mm lens and cap**
2 **spare SLR body with 28mm lens and cap**
3 **135mm lens**
4 **autowinder**
5 **electronic flash unit with tiltable head**
6 **neck straps**
7 **ultraviolet filter**
8 **transparent film case**
9 **cable release**
10 **lens tissue**
11 **lens cleaning fluid**
12 **plastic rain cover**
13 **hand-held light meter with case**
14 **tabletop tripod with ball-joint head**
15 **aluminum carrying case**

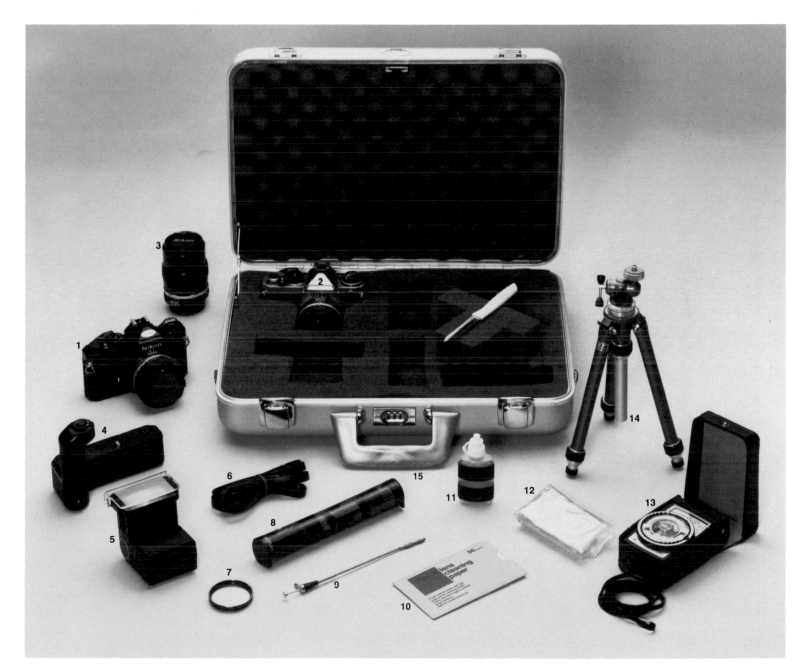

What Extra Lenses Can Do

The photographs of three Washington, D.C., landmarks at right—all familiar targets of travelers' cameras—demonstrate what the right lens can do to make a picture better, especially when barriers limit the camera's mobility. The photographer used the same 35mm camera and remained at one position for each series of pictures, shooting first with a 28mm wide-angle lens, then with a 50mm normal lens and finally with a 135mm long lens.

The pictures of the Capitol *(top row)* were taken at the west wall of the building's grounds, at a spot where the photographer was unable to move any farther back without including the wall and the street in front of it in the shot. The wide-angle lens *(left-hand picture),* giving generous lateral coverage of about 74°, provided a sweeping view that encompasses both of the structure's far flung wings and a pleasing frame of the trees and lawn as well. The normal 50mm lens *(center picture)* could not capture the great building sufficiently; the wings are chopped off and a great deal of the grassy setting is lost. The shot that was taken with the 135mm lens *(far right)* presents even worse problems; the long lens so drastically reduced the coverage that the most prominent feature of the Capitol—its dome—is cut off.

Although the wide-angle lens proved to be a good choice for the view of the Capitol, the normal lens was better suited for a picture of the White House *(middle row).* All three shots were taken with the camera poked through the iron pickets in the fence surrounding the executive mansion—another vantage point dictated by circumstances. It was the closest any unauthorized person could approach, and the photographer could not take a stance farther away without cluttering up the picture with the fence and crowds of people. (As often happens, the sidewalk was filled with political demonstrators.) The picture taken with the wide-angle lens is adequate, but too much of the image area is pointlessly used on the grounds. The normal lens produced far better results. The building almost fills the frame laterally, yet there is enough greenery to convey a sense of the environs. Attempting the photo with a long lens resulted in an image that might be considered an interesting detail shot of the portico, but one that fails as a comprehensive picture of the White House.

When the Lincoln Memorial was photographed from the far end of the Reflecting Pool *(bottom row),* the telephoto lens came into its own. The only way to get a straight-on view of the monument that also included the water was to position the camera at the edge of the 2,000-foot-long pool. The wide-angle shot gives a panoramic view of the scene, but it is dominated by the great expanse of water, and the memorial itself is too small to be the main subject of the picture. With the normal lens, there is still too much water, and the structure remains annoyingly small. The third picture, taken with the long lens, achieves a more pleasing balance. The memorial is prominent, and yet enough of the setting appears to give a sense of locale.

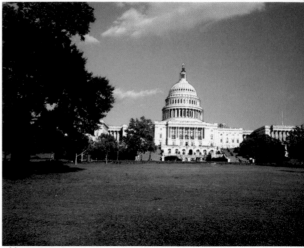

wide-angle lens

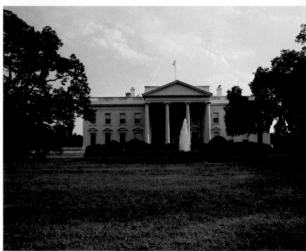

wide-angle lens

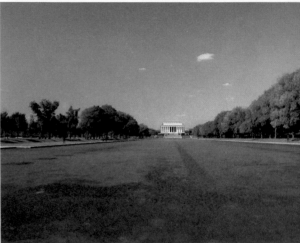

wide-angle lens

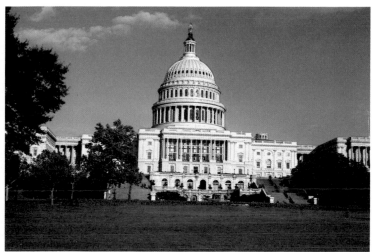

normal lens

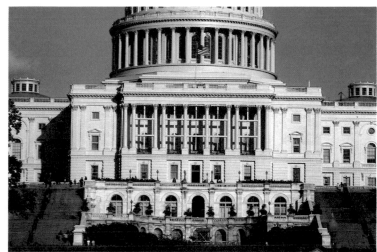

long lens

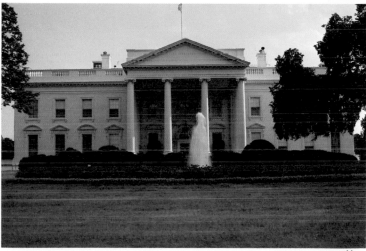

normal lens

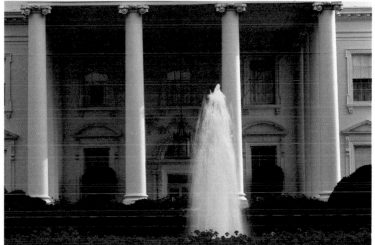

long lens

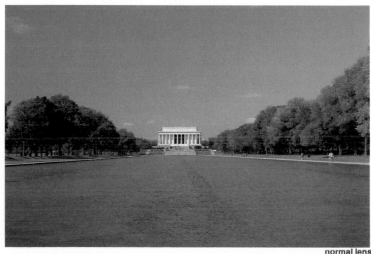

normal lens

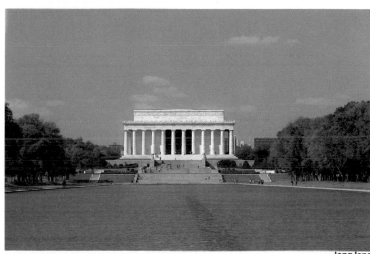

long lens

Working with Works of Art

No traveler wants to miss out on the great wealth of art—the famous sculpture and paintings, the magnificent cathedrals, and the massive monuments—that can be photographed at most tourist destinations. The pictures he is able to get of them will be much better if he has a few accessories. While professionals such as Dmitri Kessel, noted for his cathedral views *(pages 96-104)*, generally use lavish kits of complex gear, the equipment listed on pages 80-81 can make excellent results possible, as illustrated by the pictures shown here, shot with 35mm cameras inside museums.

The most useful lenses besides the normal 50 or 55mm are those of moderately long and moderately short focal length—for a 35mm camera, a 135mm long lens and a 28mm or 35mm short lens. They make it possible for the photographer to get close-ups and interesting aspects of objects that would be difficult to catch with a normal lens. They also permit the positioning of the camera in a way that excludes people who might clutter the view.

A long lens, however, may worsen another photographic problem in museums and cathedrals: the light in such buildings is often too limited to permit shutter speeds fast enough to avoid blurring with a hand-held camera, and the long lens is not only slower than a normal one, but its magnifying effect also magnifies camera shake. The usual solutions—flash to increase the light or a tripod to steady the camera—may be forbidden *(pages 86-89)*. In such a situation, a miniature tripod *(right)* can be handy. Alternatively it is often possible to hold the camera firmly against a wall or railing or even, in some cases *(opposite)*, to simply place it so that it lies flat on the floor. □

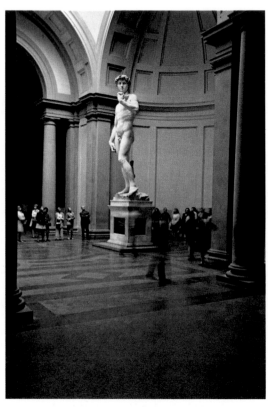
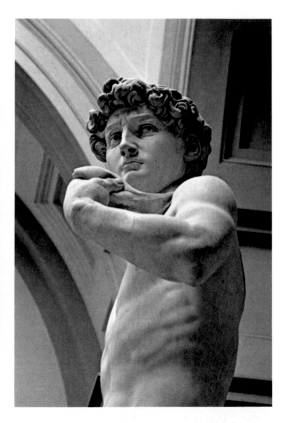

An overall view of Michelangelo's David in Florence (above) was taken with a hand-held 35mm SLR and a 50mm lens. A shutter speed of 1/30 second recorded some movement among people in the picture. For the close-up, a 135mm lens was used and stopped down to f/11 to gain depth of field. This small aperture necessitated a shutter speed of ⅛ second—so slow the camera required a solid mount. It was set on a miniature tripod with a ball-and-socket head and then held against a column at one side of the statue (right).

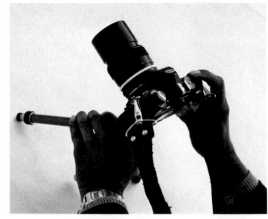

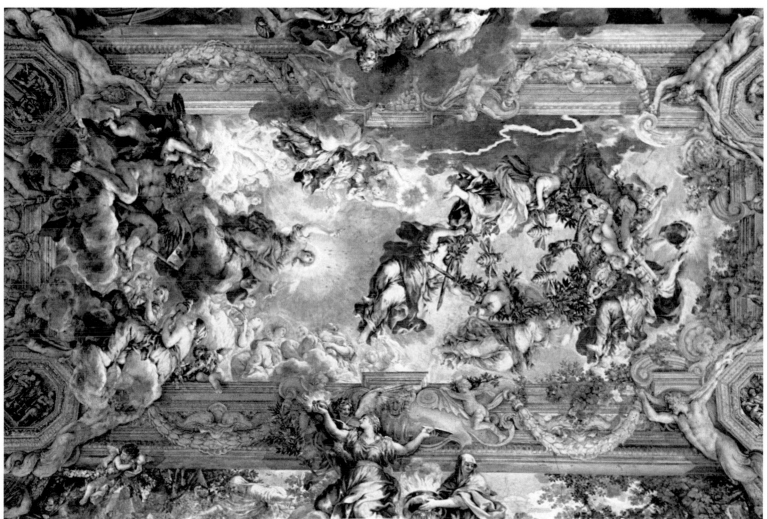

JOHN PORTER: *Ceiling in the Salone of the Barberini Palace,* 1969

*A 17th Century ceiling painted by Pietro de
Cortona in Rome's baroque Barberini Palace was
photographed with a 35mm rangefinder camera
and a wide-angle lens. The photographer focused
from a position close to the floor, then placed
the camera on its back in the center of the floor
and tripped the shutter with a cable release.*

Rules and Regulations in Foreign Lands

During the latter part of the 20th Century a remarkable thing has happened in the field of travel: the freedom to move about the nations of the world—and to photograph—has become almost universal. Today the globe-trotting photographer has unprecedented opportunities not only to shoot the standard tourist fare but also to capture more intimate glimpses of life in other lands and to compile a personal photographic collection of the world's art masterpieces. Even in many countries once sealed off behind the Iron or Bamboo Curtain, the traveler and his camera are now welcome. What is more, the restrictions that remain on camera use are generally not much more stringent than those the photographer takes for granted in America—where he assumes as a matter of course that a museum may forbid use of a flash or a tripod, and that neither he nor his camera will be allowed inside a missile silo or Fort Knox.

The limitations vary somewhat from country to country. Usually they have to do with what subject matter may be photographed, but sometimes they also involve how much equipment and film may be taken into the country. To learn in advance what subjects or gear may cause problems, the traveler should check the nearest consulate of any country he plans to visit. At the same time, it also makes sense to inquire about provisions for processing film and about whether an adaptor will be needed to recharge a flash unit. Other good sources of information on the problems a photographer may encounter in a particular country are branches of the country's tourist information service, the United States Passport Office and knowledgeable travel agents. Once inside a country, the best procedure is to heed all signs forbidding photography and, equally important, to ask when in doubt.

As might be expected, the subjects most often banned are ones that touch on national security. Almost every country forbids the indiscriminate photographing of military installations. Many extend this prohibition to strategically important border areas and to sensitive sites like nuclear power plants. In Eastern Europe, the Soviet Union, China and Cuba, the list of restricted subjects may include facilities involved with production (factories, refineries, power plants, collective farms), transportation (airports, seaports, rail stations and junctions, bridges) and communications (broadcasting antennas). Military and police personnel may also be on the list. In China, surprisingly, the street-level entrances to the Peking subway are off limits (because the subway platforms also serve as bomb shelters). Not all of these restrictions are enforced in all cases, however; often a subject that is not closely related to defense—a railroad station, a state farm—may be photographed with the permission of the official in charge or a government tour guide.

Other security-conscious nations, most notably in the Middle East, may enforce similar restrictions, especially in times of international or domestic unrest. Oil-producing countries, in particular, may ban shots of their refineries and

pipelines. Because of internal security, some countries have unexpectedly taboo subjects—among them national palaces in Haiti and Morocco, prisons in South Africa and the interiors of Switzerland's celebrated banks. Most Western countries do not care if a photographer takes a shot from a jetliner window, but ask first elsewhere, since the rules vary widely. And even in many Western countries a permit is needed to photograph from a private plane.

Other restricted subjects are not so predictable. Some countries, such as India, Jamaica and the Dominican Republic, are sensitive about poverty and forbid the photographing of beggars or slums. Religious objections to image-making are behind the bans on taking pictures of mosque interiors or of women in some Islamic countries and of certain sects in Israel. In Argentina and France, there are restrictions on photographs of cemeteries (in France, photographs are not permitted to show names on tombstones) out of respect for the feelings of the families of the dead. Even more surprising are the conservation-minded prohibitions in Iceland that restrict the photographing of eagles, falcons and other rare bird species so that they will not be frightened away from their mating and nesting areas.

One class of subjects that many photographers expect to be off limits is the great works of art in museums. But this is far from being the case. With some notable exceptions—the Prado in Madrid, the National and Tate Galleries in London—most of the major art museums (including those in the United States) allow the photographer to use a hand-held camera, and only a few require a fee or permit. Even in the U.S.S.R.—according to Intourist, the government travel agency—it is possible to make personal photographs of the country's huge collections of masterpieces; a permit is required but not hard to get.

Nearly all museums do impose some restrictions on the use of flash units and tripods, and for good reason. Not only must they ensure the safety and comfort of their visitors, who may be disturbed by a flash or trip over a tripod, but more importantly, they must do everything possible to protect their collections from deterioration, and repeated use of flash can cause the colors in oil paintings and tapestries to fade. Most museums ban flashes outright; a few will allow their use with a permit, or as in the case of the Musei Capitolini in Rome, let them be used to photograph statues but not other works of art. Tripods are also widely prohibited, but just as often a museum will limit their use by requiring a fee or permit, or by allowing them only at times when the museum is not busy. In Florence, the mid-day siesta hour, when visitors are few, is the only time tripods may be set up in that city's famous museums. Since these regulations vary greatly and change from time to time, it is advisable to check with a curator in advance of any out-of-the-ordinary shooting.

Concerning other photographic restrictions in museums, there are a few general rules to keep in mind. Photographing exhibits that are on loan is usual-

ly forbidden, since the items are not the property of the museum. Photographing works by living artists is often not permitted, to protect the artists' rights. Photographing at a museum affiliated with a church ordinarily requires the permission of the sexton — and sometimes a small donation. Some museums also restrict the photographing of certain popular artworks both to facilitate visitor traffic flow and to boost sales of their gift shop replicas. All in all, however, the art museum is a much more permissive place for photography than many tourist-photographers think. And the restrictions, especially those on flashes and tripods, are not very different from those that might be encountered in churches and other historic buildings or, as in Mexico, at archeological sites.

When it comes to restrictions on taking photographic equipment into a country, the traveler-photographer is on fairly safe ground; every country assumes tourists will be carrying cameras. Some do have regulations on the amount of gear and film that can be brought in, but the basic kit suggested earlier in this chapter *(pages 80-81),* consisting of two camera bodies, three lenses and standard accessories, would give the photographer a problem in only a handful of countries — most notably Mexico, Brazil and the U.S.S.R. Some of these nations require a tax or a refundable bond on equipment exceeding a specified limit; a few may demand the surrender of excess gear on arrival, to be returned on departure. To avoid this, check with the consulates of the countries you plan to tour; if giving up equipment is unavoidable, be sure to get a receipt. An unusually large amount of equipment may give customs officials of many nations pause; they may, for example, take a traveler with three or more cameras, or heavy-duty tripods, for a professional, and tax him accordingly. Besides imposing limits on the amount of equipment, some nations, mainly in Eastern Europe and the Third World, require that the visitor register all gear and film on arrival. In some of these countries, a good Japanese 35mm SLR is a heavily taxed luxury item that will fetch a handsome sum on the black market; keep both the registration slip and any gear, for if an item is missing on departure, a duty may be charged on the assumption that it has been sold.

Film processing abroad varies greatly in quality, speed and availability. In most industrial Western nations, the service will be on a par with what the photographer expects at home — especially if the film is sent to a processing plant run by the film's manufacturer. Elsewhere, results are less predictable, and often the special processing required for Kodachrome transparency film is not available. In any event, many travelers do not stay put long enough for the two days to a week that processing typically requires, and — rather than have pictures developed and sent to a later destination — the safest procedure is to have film processed back home. The chief hazard in doing this comes from the X-ray baggage scanners in airports. One pass through a properly regulated machine is not likely to harm film. But X-rays in quantity can fog film, and there

is a danger that the film may receive a massive dose from a poorly adjusted machine, or that repeated scannings may have a cumulative effect. The lead foil bags available in photo supply stores give some protection. But whenever possible, get to the airport early and have the film inspected visually by an attendant. Alternatively, send the film to a United States laboratory in a mailer that shows that the processing was paid for in advance. Mark the package *"photographic film—do not X-ray"* since imported goods are often X-rayed to detect contraband. (Mailers bought overseas are usually honored by the film manufacturer's U.S. plants, but with mailers for slide film, be sure the price covers mounting; in some places it costs extra to include this.)

In deciding whether to carry film or send it home, another factor to consider is the length of time exposed film can be kept undeveloped, and this depends partly on climate. In the cool air of Scandinavia, a couple of months will make no difference; in the heat of North Africa, image quality begins to deteriorate almost immediately. Excessively high humidity can also be damaging. In some areas government regulations may be the determining factor. The U.S.S.R. and some Eastern European nations restrict the importing of negatives and exposed film; they also forbid the mailing out of exposed film. So before entering these countries, mail home whatever was shot earlier in the trip, and hold onto what you shoot while there.

The traveler who expects to recharge his electronic flash unit or autowinder should also be prepared for the vagaries of electric power throughout the world. While most nations in the Americas follow the United States practice of using a current of 110 to 120 volts, the power in most other parts of the globe has a voltage of 220. The frequency is also different (50 cycles instead of 60) and the configuration of plugs and wall sockets varies greatly. Many rechargers have a switch that allow them to be used with either 110 or 220 current, and with most of these units all that is needed is a set of simple adapter plugs that permit them to be connected to various sockets. Rechargers that do not have this feature usually require a more complex adapter, containing a transformer that steps down the 220 current to 110. In any event, be sure to check on the kind of current and outlets used in the countries on your itinerary, and consult the equipment's instruction manual for how to adapt it. Backup sets of batteries are always a good idea.

The last leg of the trip is not always clear sailing, for equipment purchased abroad may be subject to United States customs duty. To avoid trouble with gear that looks as if it might have been bought outside the United States (a foreign-made camera, for example), carry some evidence—a sales slip or an insurance policy—to prove you bought it before the trip and paid the required taxes. Better yet, register the equipment before leaving by taking it to the U.S. Customs Office at the airport at least two hours before departure time. □

Photographing en Route

ALFRED EISENSTAEDT: *Twentieth Century Limited,* 1952

All too often, people begin to shoot their travel pictures only after they have arrived at their destination. But getting there is half the fun, as the Cunard steamship ads used to say; the journey presents opportunities for good pictures, like the bridge scene opposite, that appear en route. Many help introduce a travel sequence: the frontispiece of this chapter *(page 77),* Ed Edwin's picture of golden afternoon sunlight sparkling from the wing of a plane, could be the title frame of a slide show, setting the tone for a record of joyous adventure. Edwin, a freelancer, always carries a loaded camera in the air: "Some of your best views are available up there," he says.

Airplanes give unparalleled overall views, while cars, boats and trains are good bases from which to capture unusual shots of the world flashing by. But picturemaking from any moving vehicle requires special care. To minimize window reflections, try to sit on the shady side and hold the camera parallel to the glass. Never steady the camera against the vehicle, because vibration will be transmitted to blur the shot; instead brace your arms against your body, which will absorb the shaking.

Yet motion may be the effect desired, as in the picture above, which Alfred Eisenstaedt made, not from a speeding train, but of it. The viewer reads the blur as a symbol of speed.

LENNART OLSON: *Bridge at Tjörn, Sweden, 1961*

◄ *The train had just begun to move when this picture was made late on a summer evening. Fading light required a long time exposure that blurred the image, capturing the powerful surge of one of the last American luxury trains as it streaked away on its journey to New York.*

The curving sweep of a bridge was photographed in morning light with black-and-white film, which emphasized linear form to make an abstract composition. Man-made designs of this sort present themselves to the traveler along almost any highway — striking but easily missed subjects.

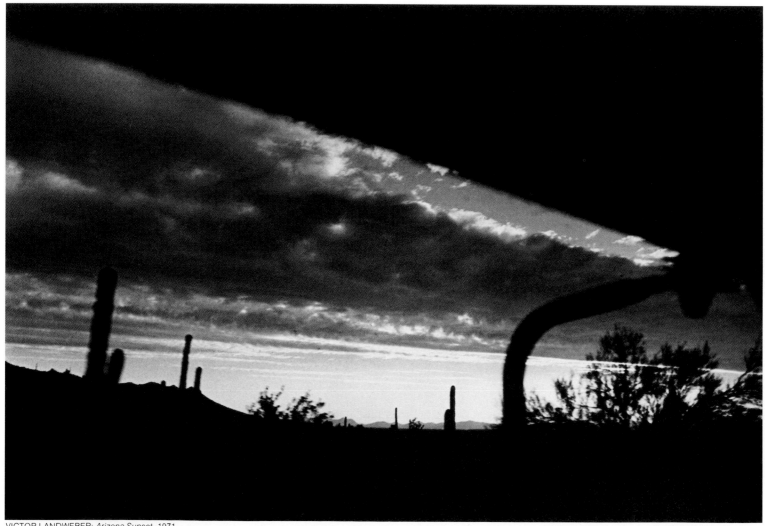

VICTOR LANDWEBER: *Arizona Sunset,* 1971

*Using his truck's windshield to frame a desert
sunset, the photographer snapped a unique,
dramatic view from an Arizona highway. The
cloud bank and the top of the windshield march
together in a tandem diagonal; what seems to be
a grotesquely twisted giant cactus is really a
metal bracket of the right-hand rearview mirror.*

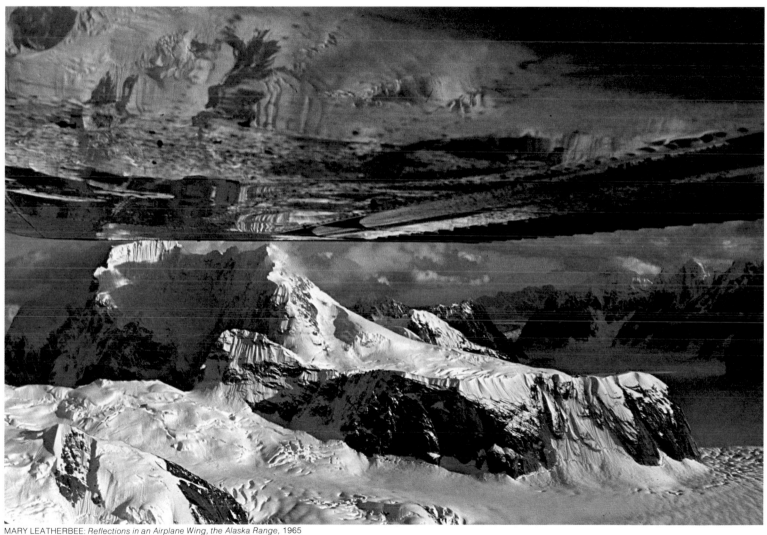

MARY LEATHERBEE: *Reflections in an Airplane Wing, the Alaska Range,* 1965

Flying near Mount McKinley in a commercial plane, Life senior editor Mary Leatherbee saw snowfields and peaks mirrored on the underside of the wing — and got this doubled picture because she always travels with a camera at the ready. Her 35mm wide-angle lens helped keep both the wing and the land below in focus.

The brave little sailboat at upper right puts
in scale this vast aerial seascape of the Atlantic
washing against the shore of Cape Cod. The
billowing light areas are sand bars, rinsed by a
foot or so of ocean water. This picture was made
from 2,500 feet on a special photographic flight
just as the plane banked on its approach
from Monomoy to Chatham, but the low-altitude
short hops of local airlines provide traveling
photographers many opportunities for such shots.

WILLIAM GARNETT: *Over Cape Cod between Chatham and Monomoy Island,* 1966

Photographing Churches: A LIFE Photographer's Guide

Once he arrives at his destination, the tourist-photographer should find plenty of fascinating things to photograph. In many places, churches are likely to be among his most picturesque subjects. Life photographer Dmitri Kessel has recorded the soaring beauty of many of the great cathedrals of the world, both for the magazine and in his book The Splendors of Christendom. On this and the following pages, he reveals some of the techniques he has developed in this difficult but rewarding field.

Nearly every time I take pictures of a church I approach it the way a painter approaches a still life. First I study the structure's components, noting the parts of it I like the most. Then I watch these parts of the building—a gargoyle, or an interior streaked by light from the windows—at different times of day, until I have found the most effective lighting. Only then do I start shooting.

I realize that the tourist visiting a cathedral cannot always wait for the best time of day. But he can walk around before he starts shooting. And, more important, he can watch for the detail that pleases him most; if he simply photographs that, instead of trying to encompass the entire place, he often gets a picture that serves as a better reminder than any overall view.

If the detail is inside the cathedral, remember that the interior light is best an hour or two before or after noontime—i.e., when the sun is not directly over the roof. The light is then bright and angled enough to come in the windows and bounce around. Watch for dust in the air in a church; shafts of light illuminating the dust particles can make a dramatic picture. Light striking a fountain or a cande-labra can fill the church's empty space. Flash can be helpful in illuminating details *(pages 99 and 104),* but for general views ordinary flash equipment is virtually useless in most dim church interiors. Some color films, however, are so fast that a good picture can be had with a time exposure of one or two seconds. To hold the camera for a time exposure, use a tripod. (If there appear to be restrictions on photographic equipment, ask permission beforehand—as you should when using flash.)

For photographs of the whole exterior of the building, get as far away from the cathedral as possible, so that the picture shows both the church's architectural beauty and the way in which it dominates the surrounding buildings. Sunrise or sunset will provide the most interesting light. Many churches are also illuminated at night, some as a feature of a *son et lumière* (sound-and-light) pageant during the tourist season.

As in many other situations when light is hard to measure, bracket widely when shooting a church at night. I had this rule impressed on me once when I was photographing the floodlit cathedral at Ulm. I was exposing at f/11 for two minutes, then four minutes, then eight minutes. While I was shooting, "Pepi" Martis, who was the peripatetic assistant to all *Life* photographers in our Paris bureau, wandered over to watch a German tourist engaged in the same task. He came back muttering, "That guy is exposing for five minutes at f/11 in *black and white.* Why don't you try 15 minutes?" Just to please Pepi, I opened the shutter and went to a nearby café for a beer. Returning 18 minutes later, I closed the shutter. That frame was the only one that was not hopelessly underexposed.　　　*—Dmitri Kessel*

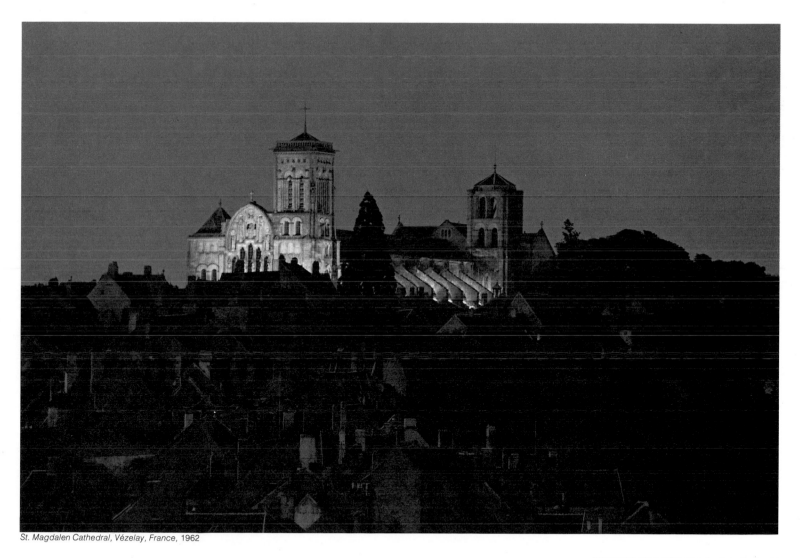

St. Magdalen Cathedral, Vézelay, France, 1962

This church offers a fine opportunity for the tourist because it is illuminated for a sound-and-light show almost every summer night. I chose a vantage point in a cornfield and waited until about 9 p.m., when there was just enough daylight left to present a blue background and bring out some detail in the houses. I used indoor-type color film in both a 2½ x 3½ view camera and a 35mm SLR.

Here is a use of natural light, first colored by
stained-glass windows, and then coloring the
vaulted columns of this side aisle of the cathedral
in Bourges. I solved the problem of getting
a high vantage point by climbing into the choir
loft. Most churches have balconies, choir lofts
or similar spots from which the photographer can
obtain a better perspective on the scene below.

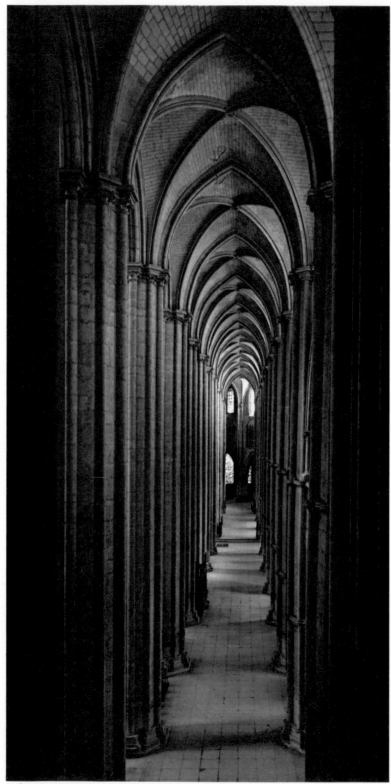

St. Étienne, Bourges, France, 1953

This stairway in Wells Cathedral is bathed in natural light from the side, but I wanted also to make sure I included some of the detail above the shaded door at the top of the picture. So I had an assistant fire two flash bulbs from the doorway at right, aimed to light up the ceiling in the center. A tourist with no assistant could get the same detail by setting his camera's self-timer, ducking out of sight behind the right doorway and setting off his flash after the exposure has started.

Cathedral of St. Andrew, Wells, England, 1953

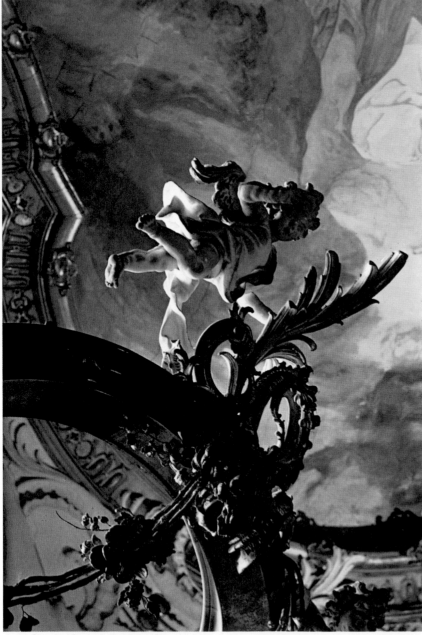

The trap to avoid in baroque churches is the scene with so many elements in it that a delight like this airborne angel gets lost in the picture. I always spend some time walking around, looking not only for what I want but also for a plain background against which to set it off. For this picture I used a 35mm camera with a 200mm lens.

Angel, Church of Our Lady, Zwiefalten, Germany, 1960

Part of the beauty of this 15th Century carving on the entrance of a pew in Ulm Cathedral —representing a sibyl, or Greek prophetess, from the legendary land Homer called Cimmeria—lies in the texture of the wood. To bring out the natural grain I used a polarizing filter to minimize the reflections and relied on natural light from the side windows. I made several long exposures at f/8, bracketing from four to eight seconds.

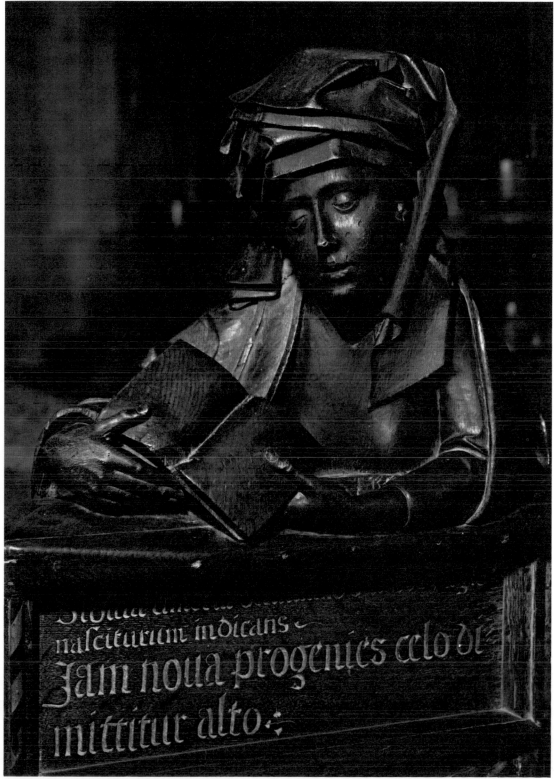

Cimmerian Sibyl, Ulm Cathedral, Germany, 1953

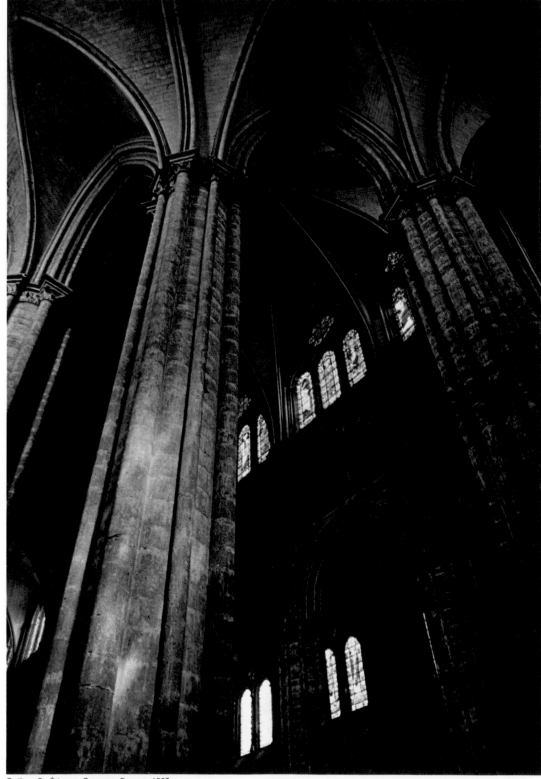

Any tourist can get a picture like this. All he has to do is take his camera into the cathedral, set up his tripod (after getting permission if necessary), aim at the lofty ceiling and take the exposure indicated by his light meter, letting the rays from the stained-glass windows provide the lighting. He should use an extreme wide-angle lens. I took this one at Bourges by aiming along the pillars, which the colored light turned into rainbows.

Ceiling, St. Étienne, Bourges, France, 1953

102

When photographing stained-glass windows it is best to concentrate on a detail rather than trying to get the whole window. Most of them are so big and so high that special equipment — a view camera or scaffolding — is needed to include the expanse without distorting some of the lines. But a detail of a window like this one can be photographed with scarcely any distortion by backing away as great a distance as the church interior will allow and using a long focal-length lens to get a large image. For the best rendition of the design, shoot when there is no direct sunlight on the glass — an overcast day is best.

Window of the Apocalypse, St. Étienne, Bourges, France, 1953

Eve the Temptress, St. Lazarus, Autun, France, 1962

*A familiar problem of lighting is the situation
in which some of the subject is better lit than the
rest of it. That's what I found in the case of this
carving of Eve in St. Lazarus Cathedral: Eve's face
and torso were nearer the window and therefore in
stronger light than the rest of the carving. I coped
with the problem by firing a small strobe onto
a sheet of white paper, bouncing the light onto the
poorly illuminated section. The same effect can
be had by bouncing a flash off a light-colored
wall, a towel or a white shirt, to provide reflected
illumination rather than harsh direct light.*

Monochrome for Simplicity and Contrast 108

LENNART OLSON: *Cloverleaf in the Snow, Stockholm,* 1953

Monochrome for Simplicity and Contrast

Most tourists pack their camera bags with color film and never give a thought to black and white. Not the professionals. They know that many of the best evocations of faraway places are made in monochrome.

Color is the popular choice for most travel pictures. Yet it often is not essential to convey the photographer's intent; it may even get in the way. In some scenes the pattern, contrast between shapes, silhouettes or overall form may provide the major interest. They are better rendered in monochrome as a rule. "Black and white allows me to reach the subject immediately, without being bothered by the distraction of color," says Ikko Narahara, who made the picture at right of St. Mark's Square in Venice.

The advantage of black-and-white film for photographing such scenes is its capacity to simplify and select the essence of the view. That essence, of course, is what the human brain registers and the camera usually cannot.

How black-and-white film performs this selecting function can be seen in the picture on the preceding page. White snow, mercifully masking the ugliness of a traffic ramp in Stockholm, is marred only by the tracks of passing vehicles, and there is an esthetic contrast between the unsullied circle and the slushy border around it.

Color film, by picking up the many different hues, might have complicated the scene so that the contrast would be missed. The oil truck at top might have been an orange color, and the structure under the steps might have borne a red sign. But black-and-white film records the impression the traveler might get from his hotel window.

To make the most of the advantages of shooting travel pictures in monochrome, advance planning is necessary. An extra camera body, already loaded with black-and-white film, may come in handy. But it is not a good idea to switch back and forth between the two film types, making one shot in color, the next in black and white. The results are likely to be disappointing. Each medium requires its own approach, and the necessary mental adjustment is difficult to make repeatedly. So to some extent the challenge to the traveling photographer is to discern ahead of time the situation that may make a better picture if he takes it in black and white.

On a visit to Venice, Japanese photographer Ikko Narahara (he uses only his first name professionally) climbed a tower over St. Mark's Square to photograph this pattern of pigeons, pavement and people. He emphasized the Square's famous "crush of pigeons" with a black-and-white composition that placed the two human figures in the right foreground and the sculptured figures as a border in the background.

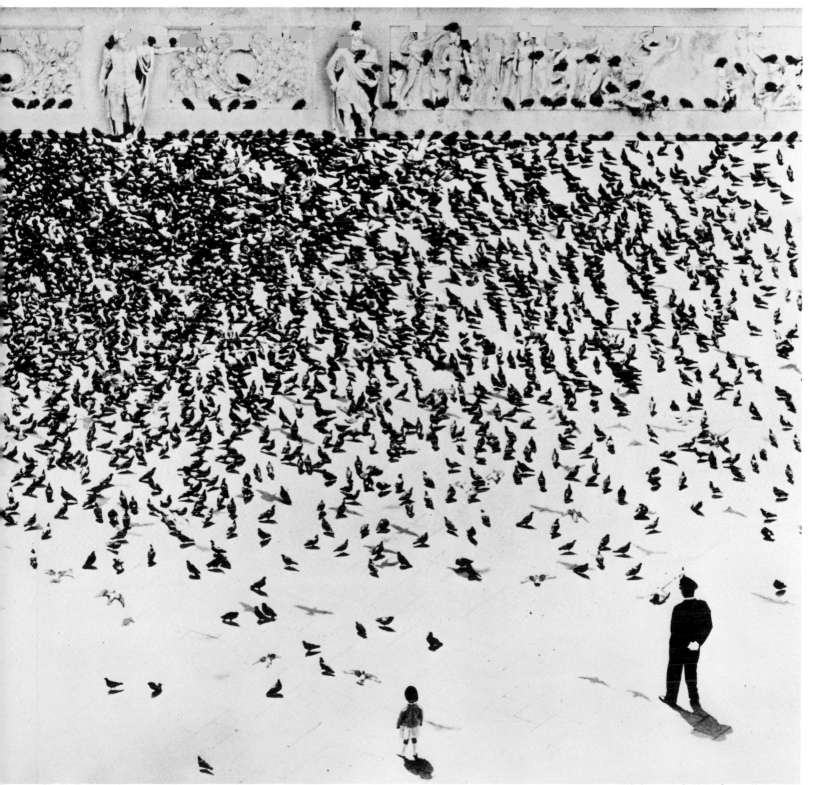

IKKO: *Pigeons in St. Mark's Square, Venice,* 1964

This quietly lyrical picture of the Pont-Neuf and Le Jardin du Vert Galant in the heart of Paris depends on black and white for its understated mood. Its elements — the arches rising out of their own reflections in the Seine, the spire of Ste.-Chapelle, the gray eminence of the Ministry of Justice rising from the mists in the background, and the solitary little figures on the embankment — are unified by the monochromatic treatment. They render a time and place as a study in tonal values — values that would be lost in color.

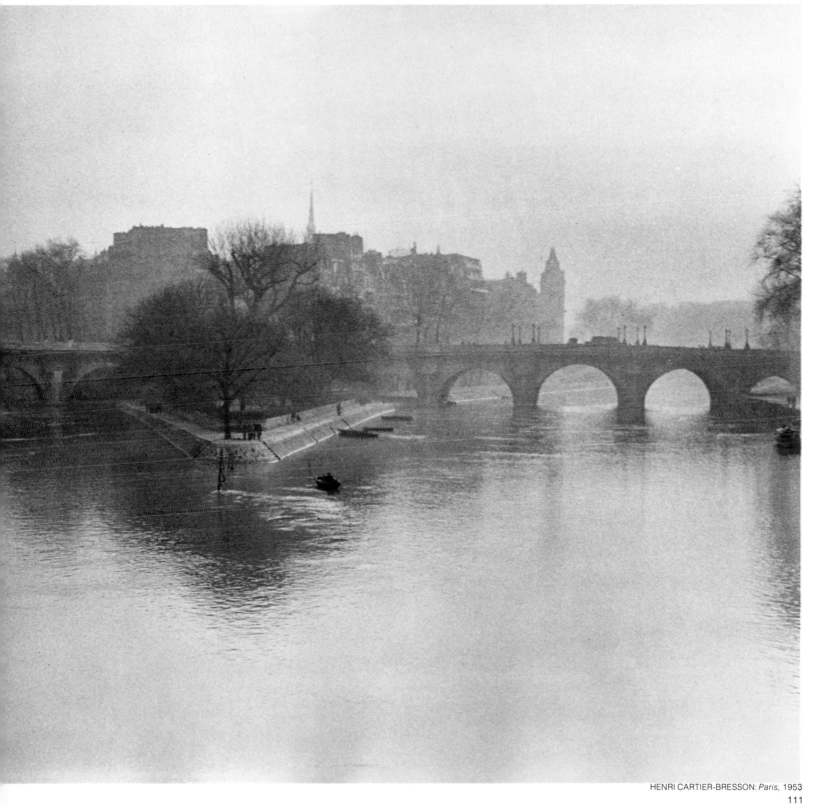

HENRI CARTIER-BRESSON: *Paris,* 1953

The chimney pots of Stockholm were photographed in black and white to emphasize their strong shapes—curiously like a row of women standing sturdily against the background of the sky. An orange filter helped increase the contrast between the tones to heighten the effect of a silhouette.

TONI SCHNEIDERS: *Stockholm Chimneys*, 1958

Religious apprentices sweep the already immaculate yard of a Shinto shrine in Tokyo. Recording this scene in black and white creates a balance between the deep, featureless shadows beneath the shrine roof and the two white-robed figures. Color might have obtruded distracting detail or otherwise upset the balance.

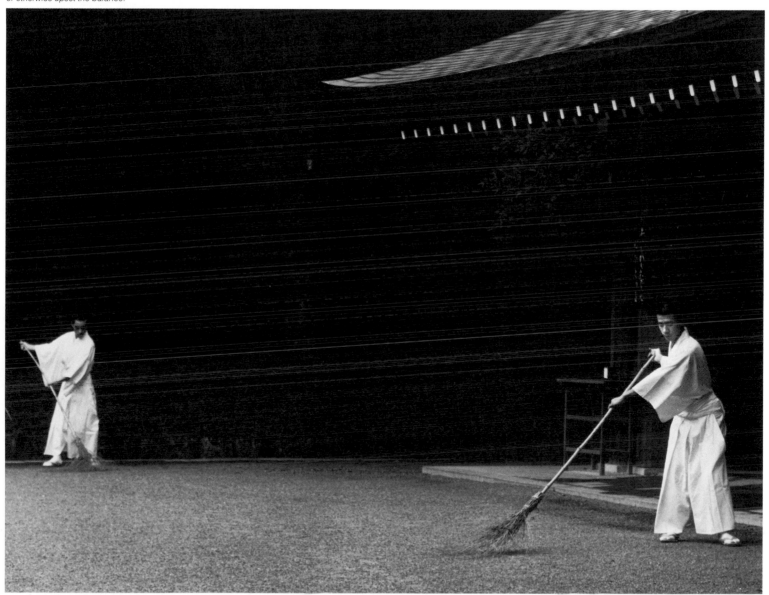

ANDRÉ KERTÉSZ: *Meiji Shrine, Tokyo,* 1968

This stark picture of Rome's much-photographed Colosseum was taken at noon when the arches and ribs of the venerable monument stood out in sharp relief under the strong sun — their bold pattern suggesting the power of the ancient empire. The picture's inky blacks and brilliant whites have something of the harsh quality of a block print, an effect that the photographer deliberately chose to intensify by enlarging and printing his picture on high-contrast paper.

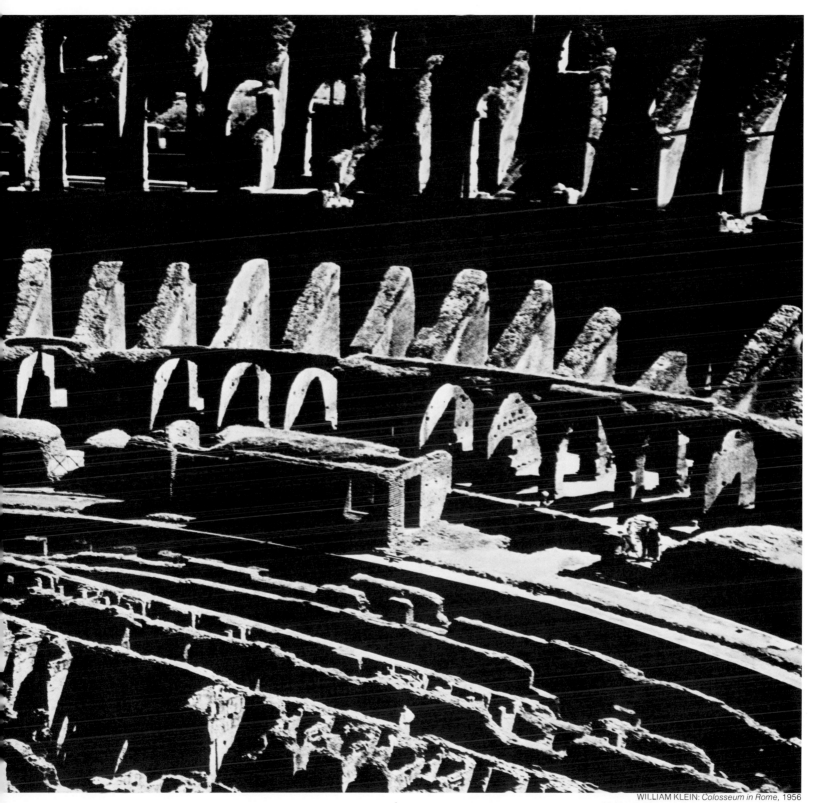

WILLIAM KLEIN: *Colosseum in Rome,* 1956

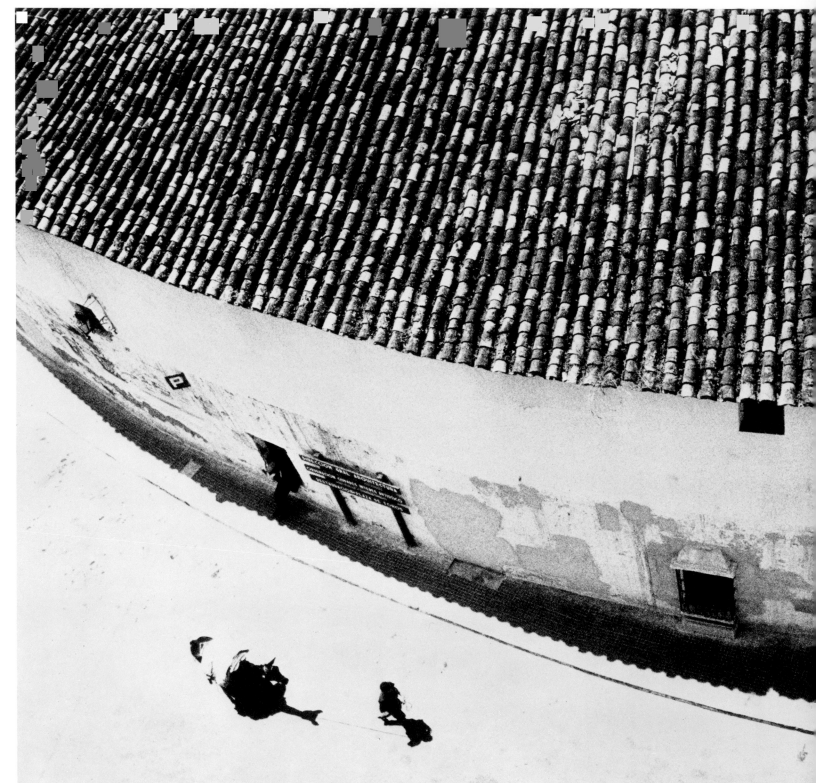

IKKO: *The Bull Ring at Ronda,* 1964

Shooting from a window across a narrow Spanish street, Ikko used a wide-angle lens for this picture of a man and donkey walking past the bull ring in Ronda. He chose black and white because it seemed to match the spirit of the country. Like many travelers, he "was impressed with the quality of the sun and shade in Spain. It is seen in the bright sun and black shade of the street," he says, "and also in the minds of the Spanish people."

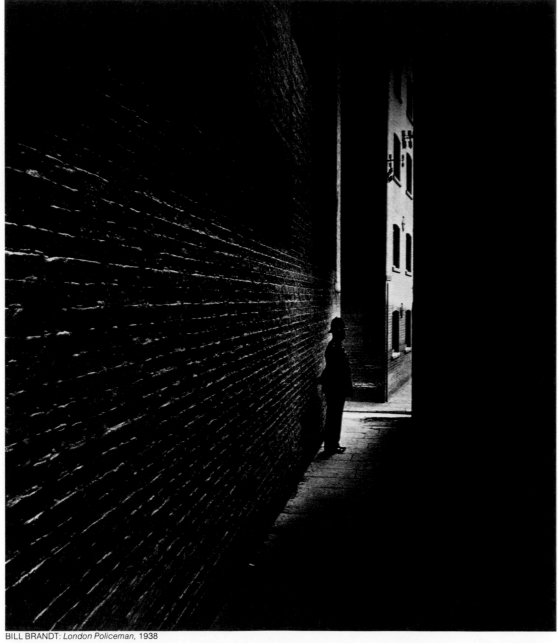

Seen from the dark end of a narrow London alley, a policeman stands in the shaft of light near the street. The black-and-white picture emphasizes the lines of bricks that converge on the figure, picking out his dark bobby's uniform and conveying the gloomy atmosphere of the alleyway.

BILL BRANDT: *London Policeman,* 1938

What looks like an intricate maze reveals its identity only when the eye travels to the top of the picture and discovers the people staring down on the photographer, who is shooting straight up past the rows of balconies on a La Plata apartment building. The striking pattern, strengthened by black-and-white rendition, makes the most of the massive rectangular masonry forms favored in the architecture of the city.

JORGE A. GAYOSO: *Apartment House, La Plata, Argentina,* 1965

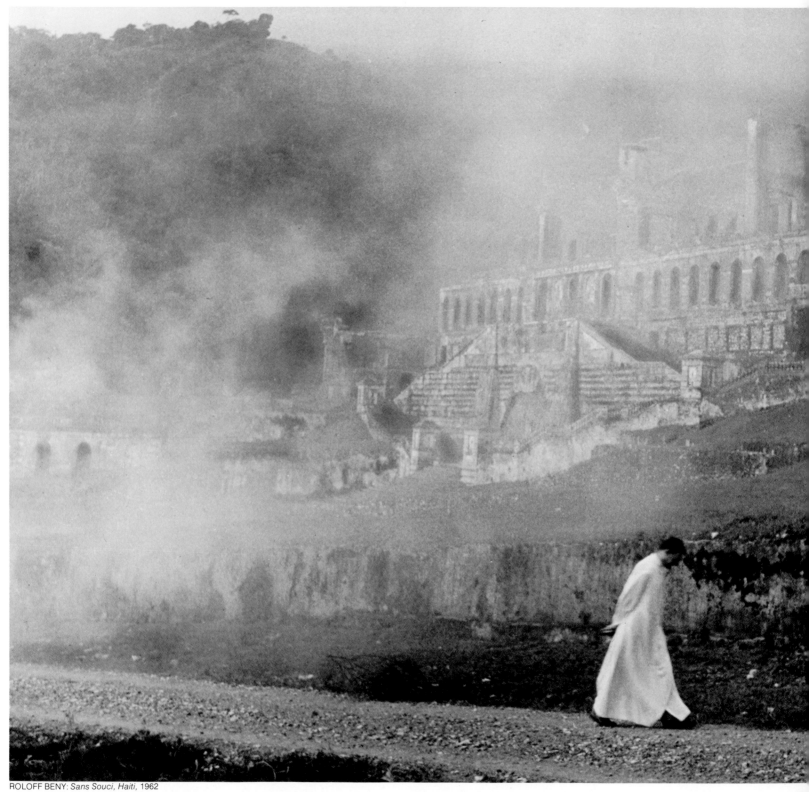

ROLOFF BENY: *Sans Souci, Haiti,* 1962

Riding horseback on a hillside in Haiti near the ruins of Sans Souci, the photographer noticed smoke rising from burning leaves in the valley below. He rushed down the road in time to dismount and catch this picture as a priest walked past the ancient palace, and smoke and mist shrouded the crumbling façade. Beny used an orange filter to penetrate the smoke and bring out the ghostly image of the ruins. He chose black-and-white film, he says, because "the nostalgia of time past is best expressed in black and white."

Koyo Okada, who claims to have photographed ▶
Mount Fuji 380,000 times, used infrared emulsion
with an orange filter to make the great symbol
of Japan seem even more awesome, towering
over a Lilliputian village huddled at its base.
The filter and film enabled him to cut through
haze that frequently softens the view of Fuji so
that in this picture the black-and-white tones
are sharper than usual, making the white-capped
peak stand out against the darkening sky.

GEORGE TICE: *Petit's Mobil Station, Cherry Hill, New Jersey,* 1974

A seemingly deserted gas station glows brightly
beneath a looming water tower. The strong contrast
of dark and light—which would have been diluted in
color—transforms a familiar roadside scene into an
arresting composition. To create a sense of isolation,
the photographer covered the lens of his view
camera whenever a car pulled into what was actually
a busy station. With the interruptions, he spent an
hour giving his film 2 minutes of exposure.

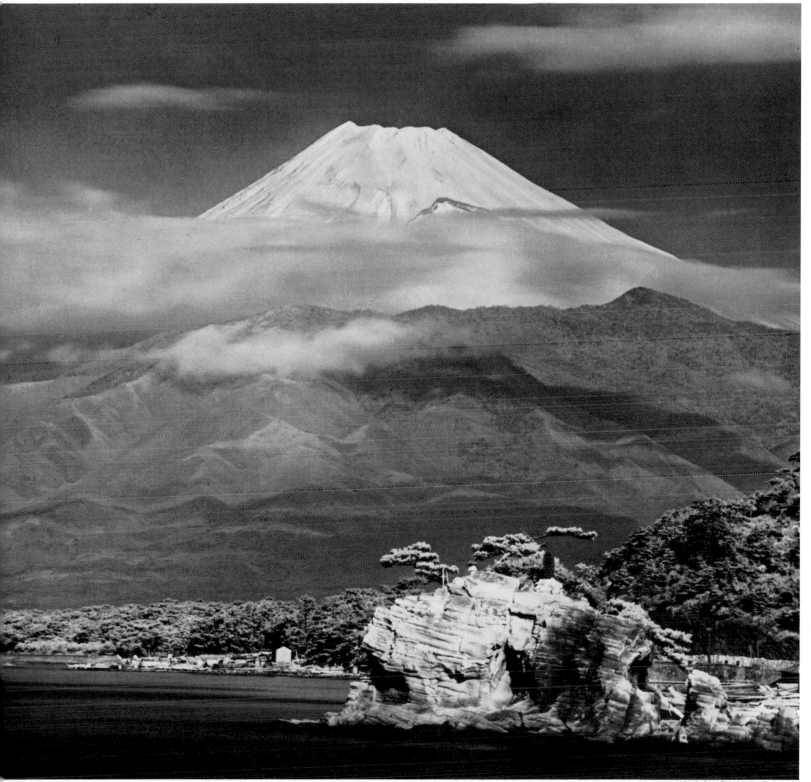

KOYO OKADA: *Mount Fuji*, 1934

JAMES RAVILIOUS: *Village Street, Exbourne, North Devon, England, 1978*

*The harmonious proportions and weather-beaten
textures of village houses in the southwest of
England are crisply captured in this picture's
broad range of gray tones. The photographer felt
that shooting in black and white would give him
control over the scene's sharp contrasts, enabling
him to bring out the shadows and highlights that
might have been obscured if he had used color film.
Moreover, he points out, "the shapes are in fact
black and white, since that is the way Devon houses
are traditionally painted."*

COLIN POOLE: *School Break in the Fog,* 1975

*School children hurrying to classes are not
usually an interesting subject to travelers, but these
boys crossing a fogbound English schoolyard
and disappearing into the mist seem to be taking
part in a strange, vaguely menacing ritual.
Although some of the boys were wearing eye-
catching yellow stockings, the photographer felt
that the singular mood of the scene would be best
captured in black and white.*

The radiance of light pouring through a stained-glass window gives an ethereal glow to a dedication ceremony in London's Westminster Hall, inspiring a mystical mood that might have been lost if color film had recorded hues introduced by the glass. The strong white rays also outline many of the participants with contrasty backlighting so they stand out as individuals in an assembly of venerable grandeur.

BILL WARHURST: *Dedication, St. Stephen's Porch, Westminster Hall*, 1952

A Sense of Place 5

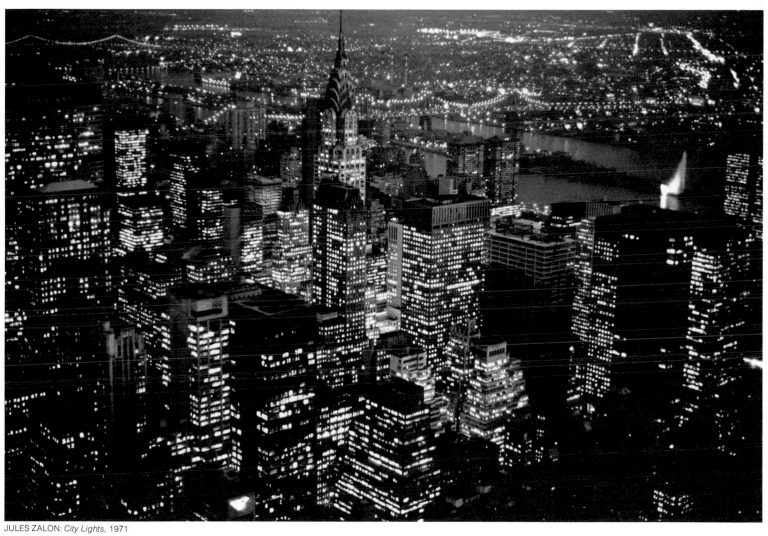

JULES ZALON: *City Lights*, 1971

Making a Memorable Record of a Site

Just as travelers of another generation set down their personal impressions in diaries, the 20th Century traveler uses camera and film to record the sights and sensations of his journeys. Like the diarists, he seeks more than mementos of events; for that purpose, picture postcards, ticket stubs and hotel receipts would do well enough. What he is after is images of pleasures past — pictures that depict as vividly as possible the special character of each place he visited, and that re-create the sensations he felt when he was there. His skill with the camera gives life, permanence and coherence to the potpourri of recollections and impressions he brings back home from a trip. Although his equipment is costlier and bulkier than the diarists' pen and paper, the photographer who chooses his gear wisely *(pages 80-83)* can be almost as nimble as the unencumbered diarist. And he has an overriding advantage over his predecessor: He can capture a fleeting scene with precision at the moment it occurs, instead of racking his brain at day's end to remember how things looked and how he felt.

The special personality of a place comprises complex and often elusive elements. The contours of the land, its climate and the imprints of its history and people are all part of local character. And rendering this flavor truthfully requires the painstaking observation of the diarist combined with the sensitivity of the portrait photographer: Many subjects sit patiently and naturally while the photographer works to depict their faces; others mug or freeze or hide, and show their true personalities only in momentary glimpses that the photographer must be alert to capture. In the same way, some places reveal character with bold, steady directness, as the sun-drenched Portuguese beach does on page 135; others, such as the Scottish island on pages 146-147, seem to withhold the secrets of their natures until a certain time of day or a peculiar weather situation comes, when suddenly they take on an air that conveys their essence.

Like human subjects, places have many unpredictable moods, and the camera is the ideal medium for depicting both the inherent, timeless ones and the fleeting, capricious ones. Every steeple, every mountain, every village square changes constantly; no scene ever looks the same twice. A city may appear tranquil in the morning light, vital at high noon, ominous at nightfall. "What is beautiful and romantic in the mists of morning," wrote the veteran photographer-traveler Alfred Eisenstaedt, "may be completely drab and uninteresting in the middle of the afternoon — and the long shadows of sunset or the dramatic clouds of an approaching storm can turn a dull street or a flat seascape into a very exciting photograph."

Eisenstaedt himself provides an example of the changeability of local flavor in the photographs on these pages of a small church in the Lofoten Islands of northern Norway — two views of the same subject taken only a few

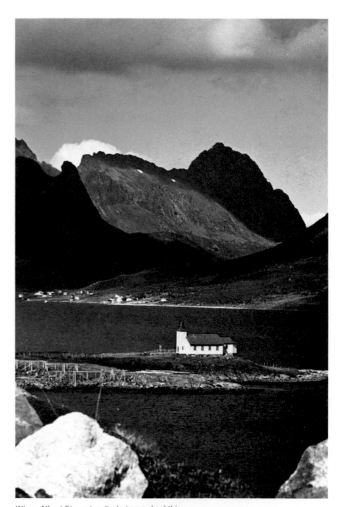

When Alfred Eisenstaedt photographed this Norwegian fjord at 10 a.m., the atmosphere was mild and comfortable. Faraway farms nestled into lush slopes and open sky make a cheery setting for the little church on the promontory.

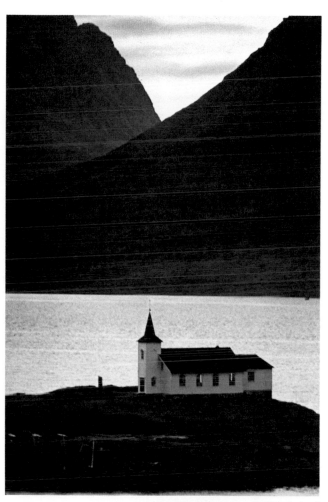

At sundown, with clouds gathering, the harsh mountains stand out in profile and shadows obscure signs of life. To emphasize the sense of solitude Eisenstaedt used a long lens, eliminating the foreground crags and all but a triangle of sky.

hours apart on the same day. In one the scene, taken in the sunny light of late morning, looks crisp and cheerful; in the other, taken under gathering clouds and shadowed by the surrounding mountains, the scene is desolate and gloomy. Both versions are true expressions of the countryside of arctic Scandinavia, two of its many aspects evoking the volatile personality of this place better than just one could.

In conveying such character, time of day may make the difference, for we associate feelings with the angle of the sun and power of light—brutal at noon, gentle in evening. Yet time, as expressed by light, is only one factor that influences perception of a scene. A scent in the air, the feeling of the wind or a peculiar noise that strikes the ear—all contribute to the uniqueness of a place. With a judicious choice of lens and camera angle, by composing his picture imaginatively and by focusing on certain things and excluding others from the frame altogether, the photographer can arrange a picture that suggests these subtler aspects of local color and mood. The photographer's purpose is to find and capture the visible signs of these unseen—but always essential—elements of atmosphere.

Recognizing the elements of atmosphere and synthesizing them into effective photographs require alertness and skill. In this case Eisenstaedt watched the clouds gather and guessed at the effect they would produce. Instead of heading for shelter, as a less venturesome visitor might have done, he took his chances with the dim light in order to achieve the dramatic second shot. An eye sharpened by experience had told him the picture was there, and worth waiting for. Such a clear eye is, in fact, one of the permanent rewards of traveling with a camera in hand. The habit of searching every scene for its often elusive value, and analyzing its meaningful components, makes the photographer more observant of subtleties and detail; he sees with a special acuteness that enriches every moment of the trip.

And when he returns home the same finely tuned attentiveness works as well in his own surroundings. The glittering diamonds-on-velvet view of Manhattan on the preceding page was taken by a native New Yorker whose travels have yielded pictures like the one on page 144. With a traveler's eye for the mood of a place, Jules Zalon watched the city. He observed the peculiar deeper-than-royal blue that sometimes falls over it at twilight, when it sparkles with the lights of office buildings, and on a December day he assumed the tourist's role. He bought a ticket to the observation deck on the top of the Empire State Building and stationed himself there for most of a frosty afternoon. With his camera propped on the railing, he exposed a whole roll of film—out of which came a picture that characterizes one of the world's most dynamic places. That sense of place—the picture that says this could be nowhere else—is what this chapter is about. □

When Time of Day Makes the Point

Time, not just timing, is one of the traveling photographer's most valuable resources. It gives a marvelously flexible way to get at the essence of a place. Every hour of every season offers a different kind of light, and every place is affected by the changing light in its own particular way. By studying the subject and watching its transformation as the day progresses, a thoughtful photographer can use this shifting illumination not only to capture the obvious elements of a scene, but also to preserve the sensations he experiences when he is there.

Not that any place has just one time when it is at its best. Moscow's skyline can be as impressive at noon as it is at dawn, and the grandeur of a Greek temple may be as well conveyed in the strange aura of artificial light after dark *(page 207)* as in the richly colored natural glow of twilight *(pages 138-139)*. Each photographer brings his own vision— and often many visions— to every place that he visits, and if his pictures are successful, takes away, in a sense, something of what he has brought there.

The towers of the Kremlin show through the fancy grillwork and the filmy curtains of a once-elegant old Moscow hotel. The photographer planned this shot in advance and waited for days to obtain it; finally early one February morning, as the sun tried vainly to burn off the haze, she saw the somber mood of the city perfectly enhanced by a heavy gray sky and smokelike billows of clouds.

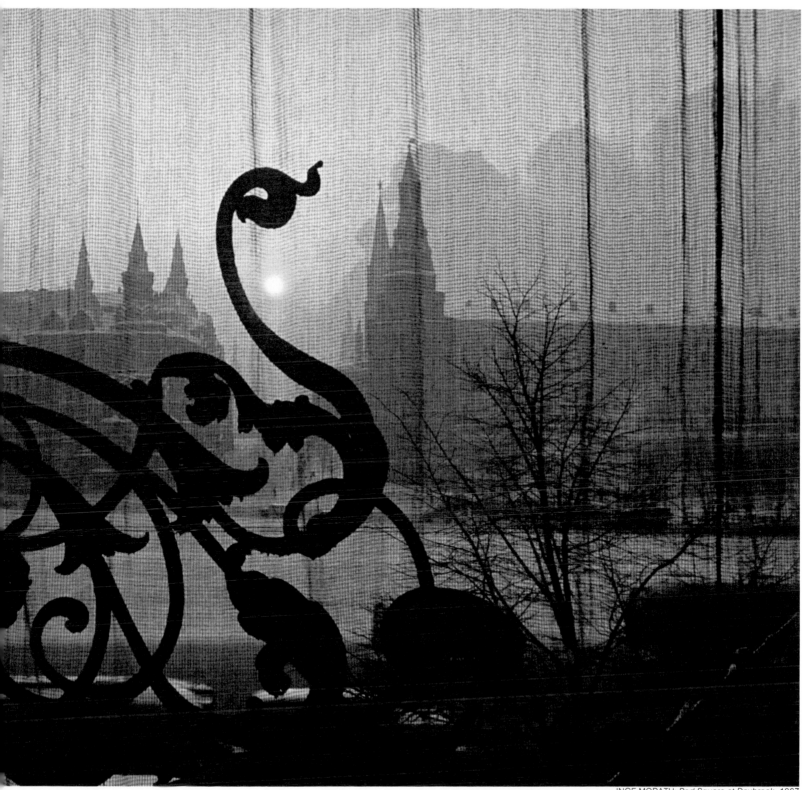

INGE MORATH: *Red Square at Daybreak*, 1967

CONSTANTINE MANOS: *Aegean Promontory*, 1966

*On the Aegean island of Skópelos off the coast
of Greece, the midday sun seems to polish
everything in sight and to chisel every edge with
shadows. The tiny figure of a man (lower left)
is dwarfed by an old Orthodox church; the
gleam of his white shirt seems almost lost
among the flecks of light that glint off the water.*

BRIAN SEED: *Beach at Nazaré,* 1956

*Boldly painted high-prowed dories, beached
after the morning's fishing, dominate a wide-angle
view of a Portuguese village, peaceful and still
in the heat of the day. In a sliver of shade an old
fisherman escapes the early afternoon sun;
only a carefree child is active — swinging on a
rope rigged on the gunwales of two boats.*

DANIEL KAUFMAN: *Sandymount, Dublin, County Dublin, 1978*

Mellow light from the late afternoon sun rakes across a Dublin storefront, casting dramatic, outsized shadows on the colorful façade. The sense of tranquillity created by the waning sun is emphasized by the relaxed air of the pipe-puffing newspaper reader as he enjoys the day's last warming rays. Although the picture's balanced composition suggests advanced planning, it actually was taken hurriedly from the photographer's car window.

Against the purple of a cloud-covered English sunset, the towers of Lincoln Cathedral stand out of an otherwise empty landscape. The vapor rising from the cooling system of a factory in the foreground serves to heighten the dreamy, end-of-day mood, and it seems suspended like a wispy curtain between camera and subject.

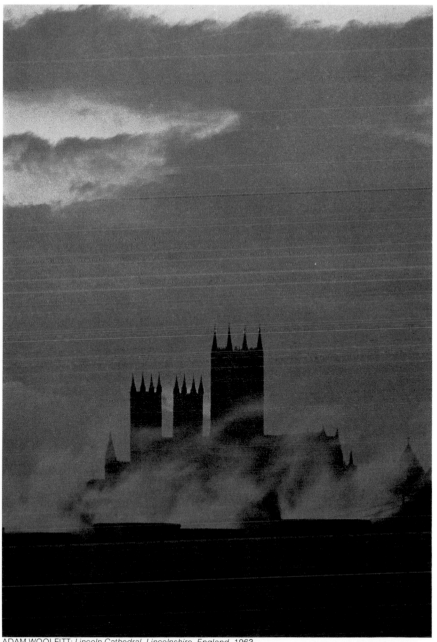

ADAM WOOLFITT: *Lincoln Cathedral, Lincolnshire, England,* 1963

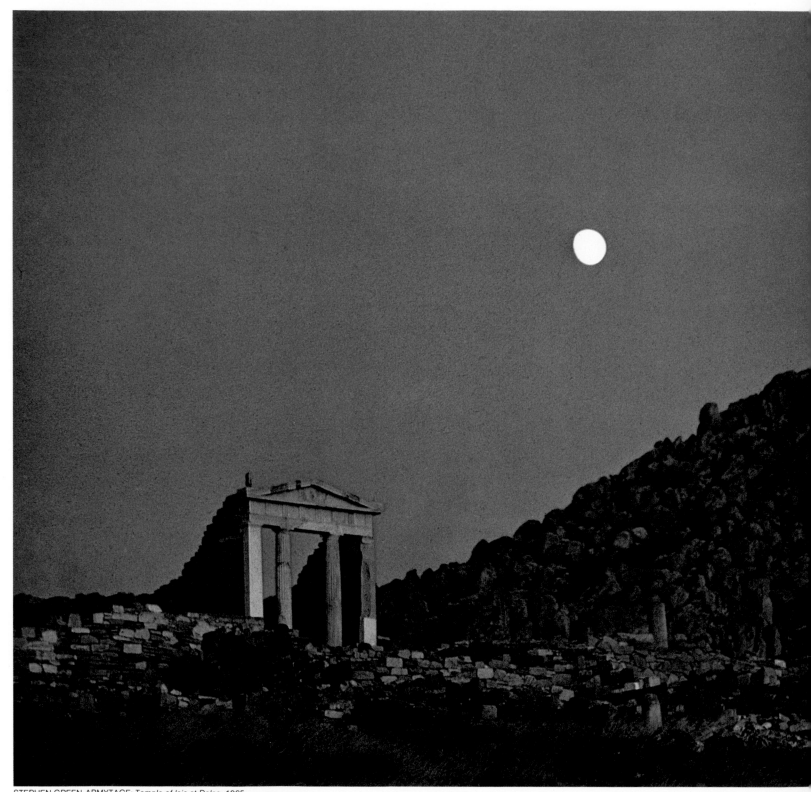

STEPHEN GREEN-ARMYTAGE: *Temple of Isis at Delos,* 1965

Just after sunset, the lingering daylight and the radiance of an almost-full moon combine to impart deep shadows and a golden hue to the marble ruins of a Greek temple. By silhouetting it alone against barren rocks and a cloudless sky, the photographer succeeded also in capturing a sense of historical time: No traces of modern life intrude on the mood of this ancient holy place.

*At 6 o'clock on a winter evening, the floodlit Georgia
Capitol glows in a misty stillness that has settled on
downtown Atlanta. Silhouettes of a statue and trees
frame the building with stark shapes, heightening the
peculiar aura of the fog and the darkness.*

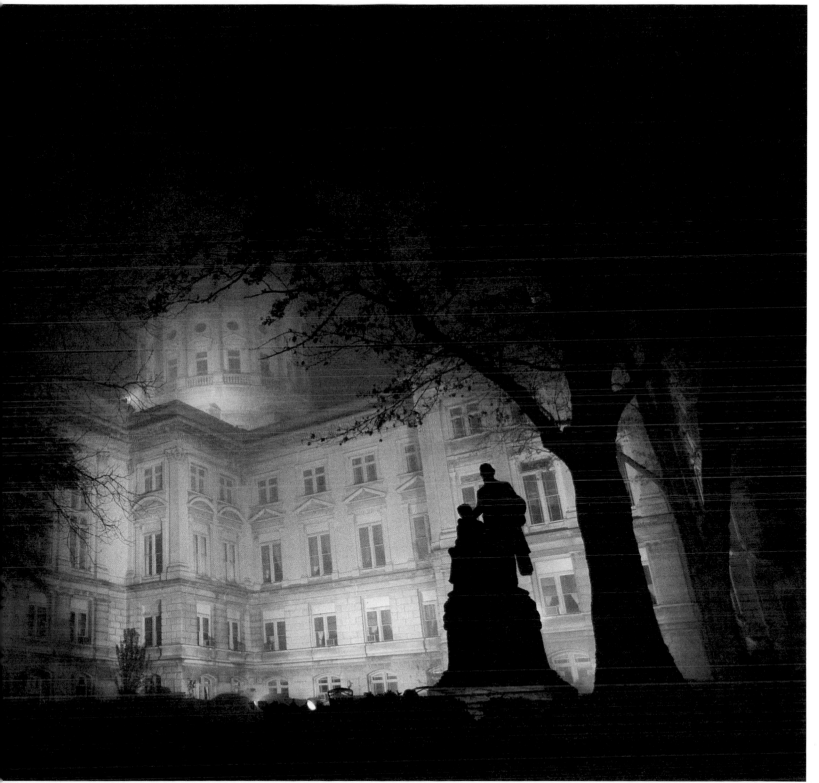

BILL WEEMS: *The State Capitol, Georgia,* 1977

Bad Weather, Good Pictures

If there is any rule about weather that governs travel photography it is: Break the old rules. Try shooting into the sun if there is a remote chance for a good picture; if dim light is all there is, shoot anyhow despite the risk of underexposure. Above all, do not allow snow, rain or fog to limit picturemaking. Some of the most evocative travel scenes were taken by photographers who ventured out with their equipment on those days when both traveler and camera could have remained safe and dry—but gathering no memories—back in the hotel room.

Bad weather often imparts a mood, suggests a particular time or even enhances a composition. An overcast sky made a perfect backdrop for the picture at right, transforming the delicate hues of the flowers into a gemlike cluster of color; in blazing sunlight, they would have competed with a brightly illuminated background and would have seemed less important. It took a grim, rainy day to present the unique view of Notre Dame cathedral on page 144.

Standard devices like lens hoods and haze filters can protect lenses from the elements. But makeshift items such as raincoats, umbrellas and plastic bags can also keep water out of equipment.

Veiled in a heavy summer haze, China's Great Wall seems to ascend into the heavens. The selection of a foggy day to shoot this scene served the photographer in two ways: It suggests the wall's staggering 1,500-mile length; and it enhances the array of delicate colors of the wild-flower bouquet in the foreground.

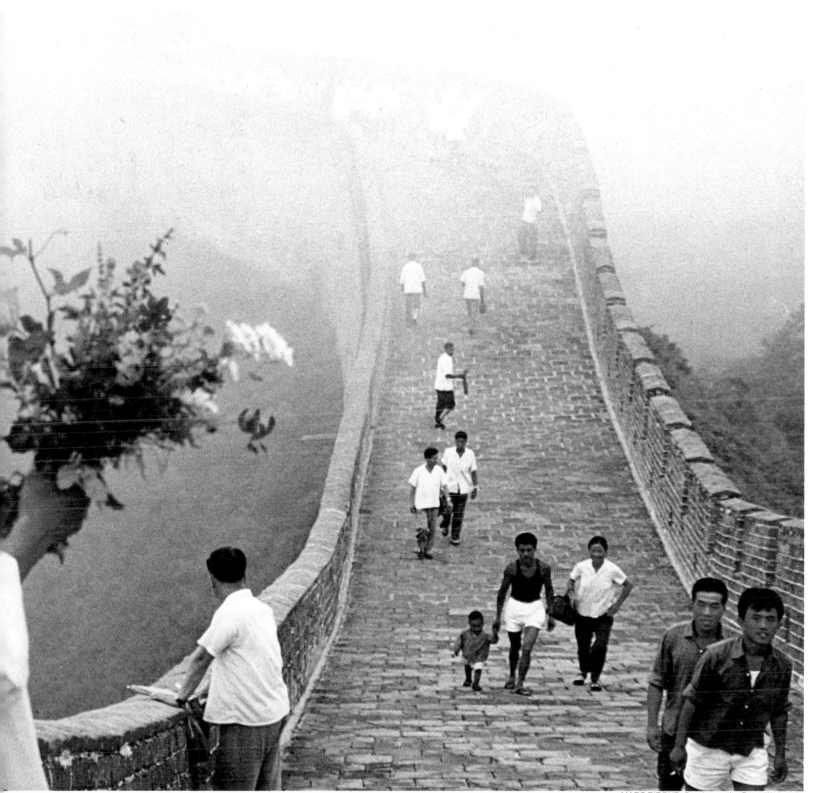

MARC RIBOUD: *Sunday on the Great Wall*, 1971

JULES ZALON: *Paris in the Rain,* 1963

*On a wet day that could make the most
determined tourist want to stay in his hotel,
photographer Zalon ventured out and captured
this unique traveler's-eye view of Notre Dame.
Through the rain-splattered roof of a tour bus, he
saw a shadowy visage of the cathedral's stone
towers. A wide-angle lens's extended depth of field
keep both droplets and building in focus.*

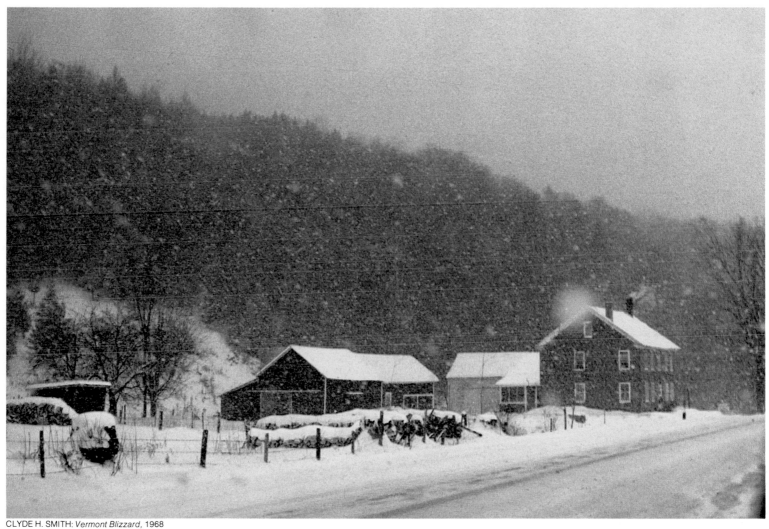

CLYDE H. SMITH: *Vermont Blizzard,* 1968

As any New Englander can testify, rural Vermont
can possess an ironic feeling of warmth even
when the temperature is below freezing and the
land is blanketed with snow. The photographer
chose to capture this comfortable sensation
by shooting during a January blizzard; the muted
red of a farmhouse and barn contrasts with the
gray sky like glowing embers on a stone hearth.

BILL BINZEN: *Lismore Island, Scotland,* 1971

The mood conveyed by a threatening sky, rather than the physical contours of thinly populated Lismore Island, was the objective in this picture. The North Atlantic island is only nine miles long, but the solitude a visitor feels makes it seem vast. To emphasize this sense of lonely desolation the photographer used a wide-angle lens that made the landscape surrounding his human subjects appear larger than it really was, and backlighted them against the gathering clouds that promised a sodden, blustery night.

Capturing the Unique Atmosphere

Capturing in one frame the whole atmosphere of a place is an ambitious goal, yet nearly every traveling photographer sets it for himself. To achieve that aim, he must analyze his subject and his personal reaction to it, constantly asking himself, "What is it that conveys to me, here and now, the special, unique character of this place?"

At first the elements of mood may seem to defy analysis, let alone photography. Some of the most important are invisible, incapable of being recorded directly on film. Yet such qualities as warmth, desolation, antiquity, sound and smell all play crucial roles in fortifying the impact of sight. So the difficult—and yet most rewarding—task is to make a picture that connotes more of a place than the sum of its visual components. The camera can be used to translate nonpictorial attributes into a picture that stimulates more senses than vision alone.

There are standard clues that can guide the photographer in his job as mood-interpreter: Reddish tones usually suggest warmth, and columns, arches and window frames are often useful devices to suggest age. But the photographer's most reliable tool is his own feeling about a place. For his personal reaction must determine how he sets his camera to render the many aspects of atmosphere in the language of color, shape, contrast and composition.

MELVIN INGBER: *Amiens, France,* 1969

A weathered ramshackle house by a canal suggests the comfortably aged mellowness the photographer sensed in the venerable city of Amiens in northern France. The raking light of the late-afternoon sun enriches the bronze hue of cracking walls and blackens the shadows in the crevices of masonry exposed by fallen stucco.

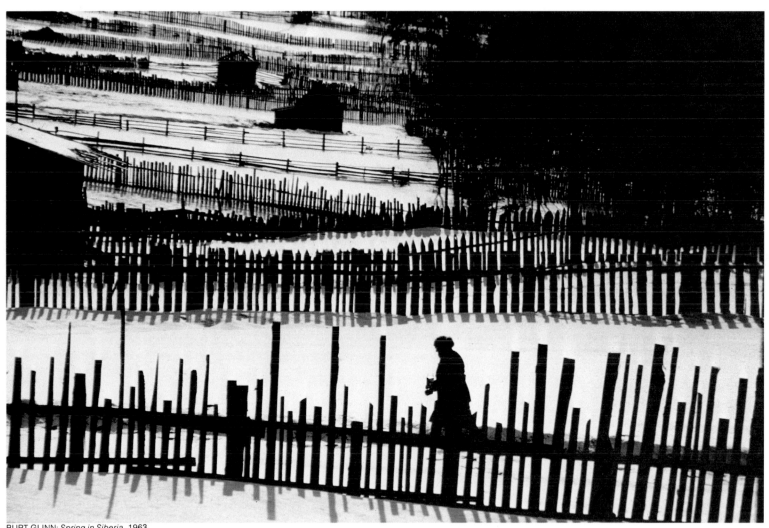

BURT GLINN: *Spring in Siberia,* 1963

*Fences marking off tracts on a collective farm
zigzag across a seemingly endless Siberian slope.
A solitary peasant woman, swathed in woolens
against the harsh wind, carries a pot of preserves,
which provides one dash of color to offset the
starkness of the landscape; otherwise, the scene
is a cold composition in black and white.*

PATRICK THURSTON: *Albert Pub, Victoria Street*, 1967

A long nighttime exposure, taken from the outside looking in through etched-glass windows, captures the warmth of a historic London pub. Old-fashioned chandeliers, their lamp shades slightly askew, hint at the tipsy afterglow of much good brew and an ever-present aroma of hops.

SHELDON COTLER: *Ljubljana Street Corner,* 1968

*By shooting reflections in a convex traffic mirror
at an intersection, the photographer managed
to get a wide-angle view of this Yugoslavian street
corner with a 135mm lens on his 35mm camera.
Irregularities in the mirror surface emphasize the
wobbliness of aging houses and shops.*

MATTHEW MILLER: *Île de la Cité*, 1967

To portray the chaotic jumble of Paris rooftops
—and avoid jostling tourists in the streets
—the photographer climbed the topmost
tower of Notre Dame and leaned over a parapet
as far as he dared, his wife gripping his belt.
The cathedral appears only in the row of
sculptured stone turrets in the foreground, far
below the camera's dizzying vantage point.

Against the plate-glass façade of a newly built
office tower in Manhattan's financial district,
Trinity Church projects a defiant symbol of 19th
Century piety and elegance. The picture is a
double exposure, one of many made by this Paris-
based photographer to illustrate the striking
modernity of the American city he often visits.

FRANCISCO HIDALGO: *Wall Street*, 1971

MARY LEATHERBEE: *A Sun-beaten Granada Hillside from the Alhambra,* 1966

A Multiple Portrait of Yosemite

HARALD SUND: *Top of Bridalveil Fall*, 1971

Although one picture can frequently sum up a traveler's feeling for a place, many travel experiences are too rich and varied to be captured in a single photograph. Some subjects are visually complex, like Disneyland or Angkor, and deserve detailed scrutiny; indeed this complexity may be what makes them tourist attractions. And sometimes a traveler's rapport with a place is so intense that only a series of images, made in the course of several visits, can properly do justice to all the moods and nuances he wants to remember after he leaves.

Two such composite portraits are exemplified on these and the following pages. The first explores the spectacular glories of Yosemite Valley through the eyes of three photographers: They approached its rock and waterfalls not as standard tourist sights but as challenging confrontations with the natural world. (Part of the challenge is the topography of the place: Its high-rising masses of stone screen out much of the light in the sky.) Taking advantage of unusual conditions of weather and time of day, capitalizing on the chance coming together of provocative visual elements, the three managed to infuse the Valley's familiar sights with new meaning. The other composite portrait, beginning on page 162, encompasses one photographer's very private feelings for the Spanish earth and the Spanish soul.

In the late-morning sun Bridalveil Fall plummets almost its full height of 620 feet in deep shadow. Only its lofty crest, torn by the wind, sparkles like crystal against a cloudless blue sky. To sharpen the contrast, the photographer underexposed—and turned the scene into an abstraction of wind and water.

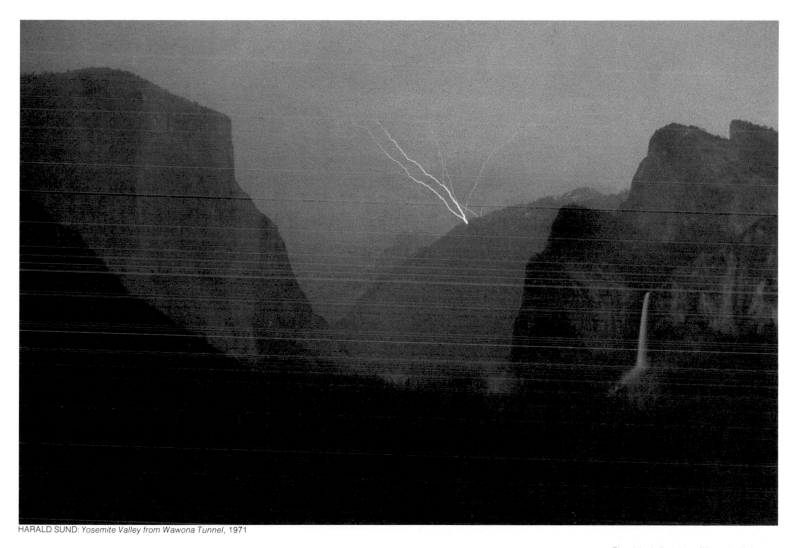

HARALD SUND: *Yosemite Valley from Wawona Tunnel, 1971*

The visitor's first view of Yosemite Valley — a sudden, breathtaking vista — is usually photographed in daylight, but Sund chose dusk, when meadows and cliffs lay shrouded in ghostly silence. Working with almost no light, he exposed his film 10 minutes and hoped for illumination from lightning in an oncoming storm: It worked.

DAVID MUENCH: *Reflection of El Capitan in Merced River, 1970*

One of the most photographed rock faces in
America and as integral to Yosemite as Bridalveil
Fall, El Capitan is seen here afresh. The granite
outcropping, twice the size of Gibraltar, is
reflected upside down among snow-crusted rocks
in the river far below — its size diminished but the
sheer verticality of its southeast face intensified.

At the end of a wild and windy day, when ▶
Yosemite had put on an extravagant weather
performance, the photographer caught the
valley in another mood, one of almost Oriental
quietude. The evening fog was rolling in,
shrouding the rocks, softening the lines of sturdy
juniper trees, fusing earth and air into one.

DAVID MUENCH: *Juniper in Fog above Tonyana Canyon*, 1970

ROBERT WALCH: *Half Dome*, 1966

*Two views of Half Dome, both of them shot after
sunset, combine to convey quite dissimilar
aspects of the ancient rock's unrelenting granite
face. In the scene above, the photographer
captured a strangely ethereal quality that
the harsh rock took on at nightfall. The bluish
cast of his picture comes from using indoor film.*

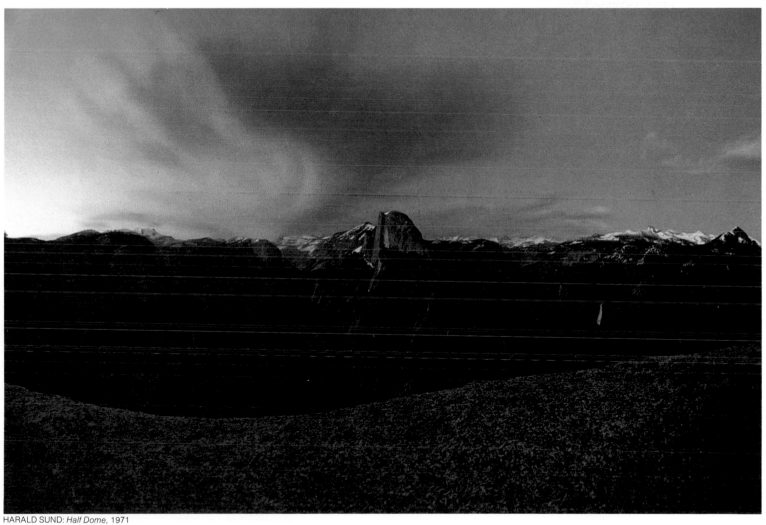

HARALD SUND: *Half Dome,* 1971

A second version, above, expresses Half Dome's timelessness in the midst of change. Using an extreme wide-angle lens to make the dome stand alone in a broad landscape, the photographer exposed for 3 minutes, 20 seconds — blurring the last warm rays of the sun on a moving cloud while the rock remained cold and immobile.

One Man's Spain

Increasingly, the traveler's itinerary is not 21 countries in 21 days but a close inspection of a single country or even of a single area of a country. This kind of thoughtful travel enables the photographer to make a much more detailed and intimate record of the impact of a place upon his mind and eye—to sum up in a series of photographs just what makes the place special to him.

For Michael Kuh, an American photographer whose pictures appear here and on the following pages, the special things about Spain are "its clear Castilian light, even better than that of Greece," its majestic landscape and its forthright people. But the traveler who proposes to capture such qualities in pictures must have done his homework. He must understand his subject before he shoots it, and try to sense what is going to happen before it happens. "How, for instance," Kuh asks, "can you know the decisive moment in a bullfight if you are ignorant of bullfighting?"

Kuh's Spain, as it happens, has little to do with bullfights. What fascinates him about Spain, and what he expresses so clearly through the cumulative effect of his collection of pictures, is the lyrical quality of life in the Spanish countryside.

Along the route of the ancient pilgrimage to Santiago de Compostela in northwest Spain, the verdant open countryside looks as it must have appeared to countless thousands of pilgrims —like the promised land. The wild flowers and weeds that Kuh found at the edge of the road provide a doorstep into the medieval landscape.

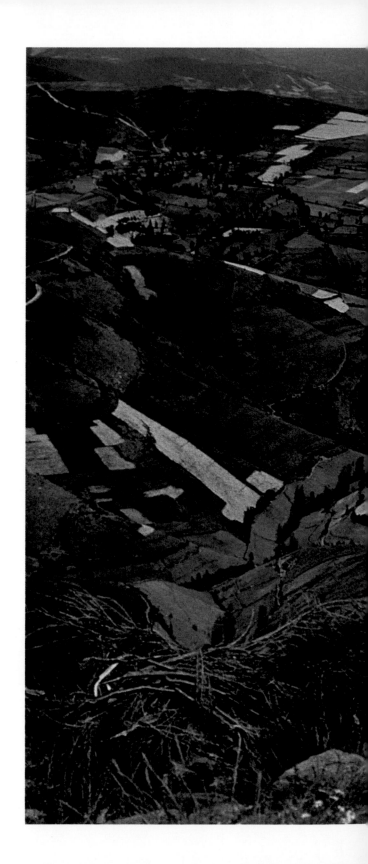

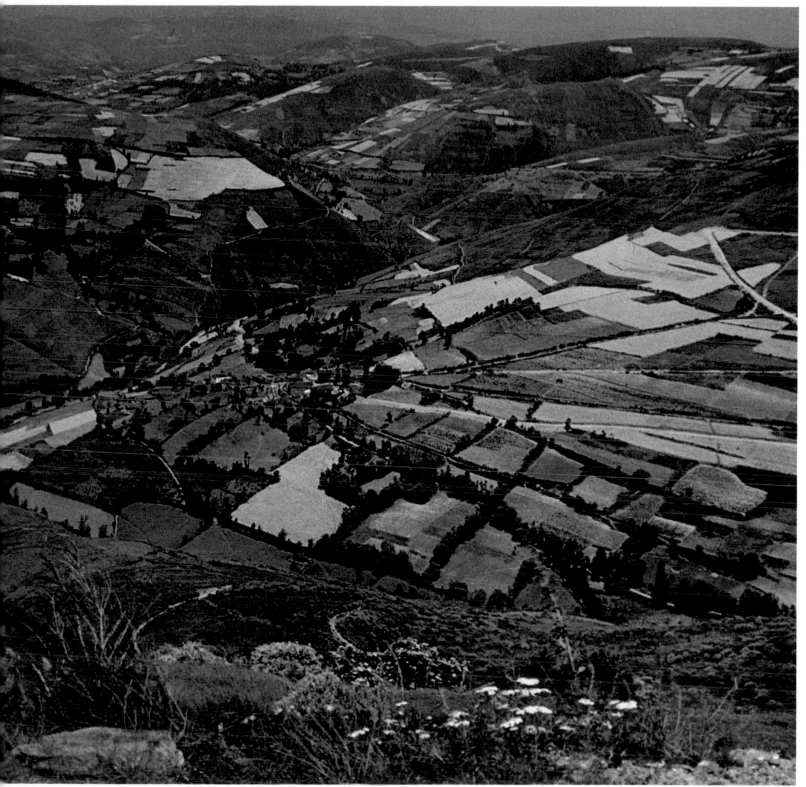

A Landscape in Galicia, 1968

To Michael Kuh, his photographs of the Spanish people reveal as much about their country as his landscapes. He lived among them for 12 years, and sought with his pictures to celebrate their self-reliance. A Spanish peasant, Kuh says, has "a self-respect, a dignity and a code of honor that I admire entirely. You cannot flip him a 1,000-peseta note and expect to push him around. 'Thank you,' he will tell you politely, 'but I have already eaten today.'" Through courtesy, an investment in time, quick thinking and occasional cunning, Kuh succeeded in revealing the inner strength that dignifies rural Spaniards at work, at leisure and participating in the various festivals that mark the Iberian year.

Though the Spanish peasant is generally sober and severe, sometimes he betrays another side of his nature. On a mountain near Roncesvalles (above), Kuh met a shepherd strolling with his dogs in the late-afternoon sunshine. "I liked his rugged face," says the photographer, "and the gentleness of his hand."

A Shepherd with His Dog, 1968

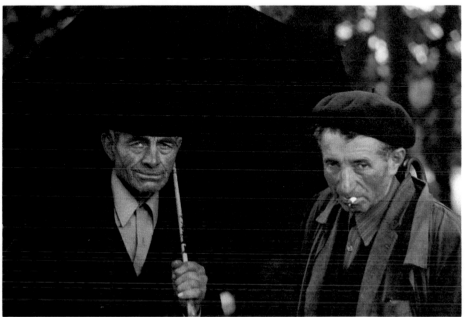

A Farmer with an Umbrella, 1970

Kuh's portrait of the Spanish people is made up of many individual photographs that reflect some of the variety of the population itself: the amused, tolerant glance of a Galician farmer (top right) peering from under an umbrella, and the shrewd face of a gypsy trader with an elegant Arab mare (right), clowning and talking with a friend at the Córdoba horse fair.

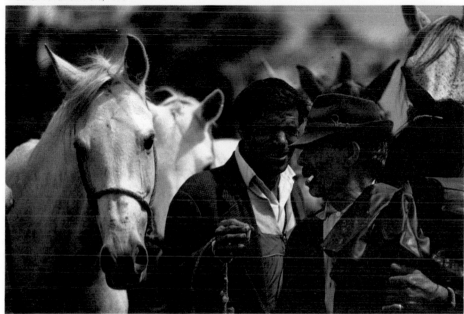

Gypsies at the Horse Fair, 1969

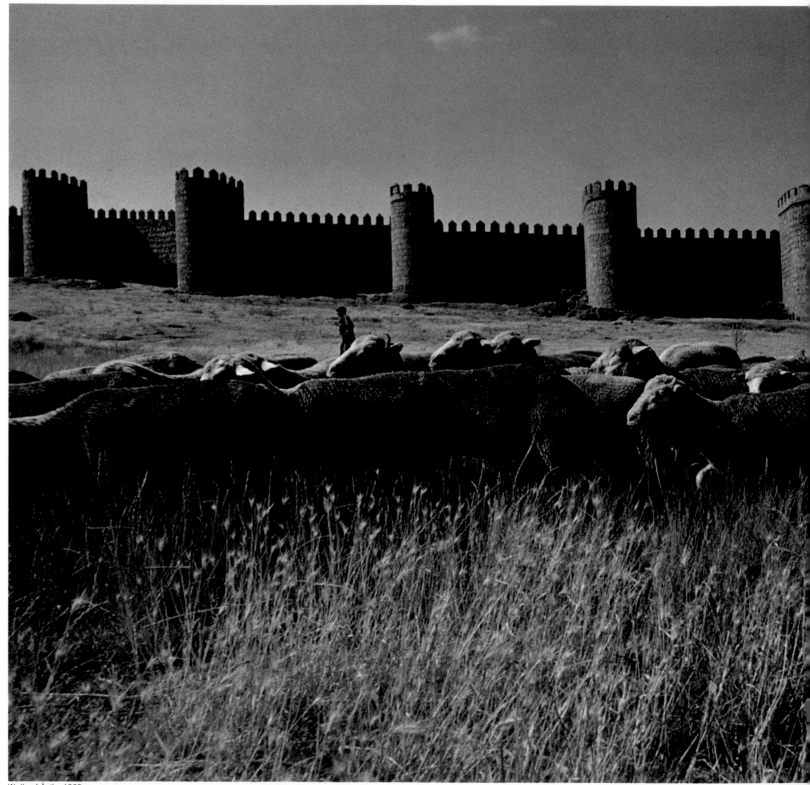

Walls of Ávila, 1969

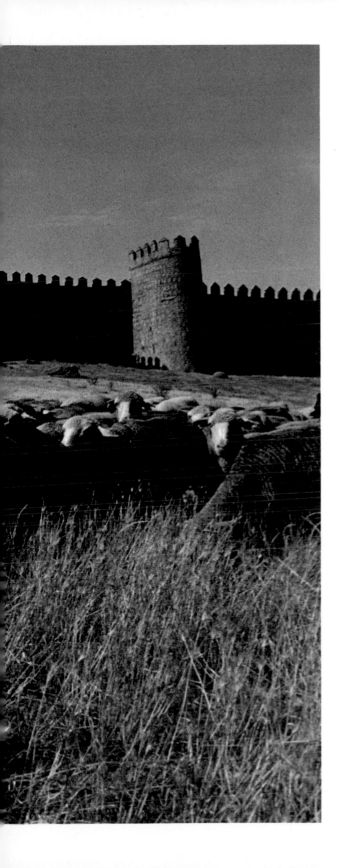

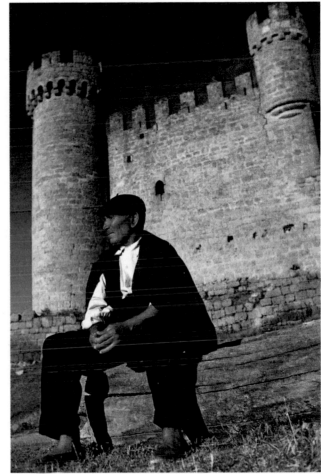

At the Castle of the Counts of Cartagena, 1968

On every hand in Spain, the romantic past and
workaday present intermingle. Outside a noble
castle in Castile the photographer met a villager
"who had gone out there to sit, to escape his
wife's conversation." They in turn struck up a
conversation that led to a picture in which
the peasant's dignity matches that of the ruin.

◄ The medieval towers and battlements of Àvila in
central Spain, left, once guarded a great religious
seat; now the place is a provincial backwater.
Both Àvilas merge in one picture of a flock
of dusty sheep bobbing past the ancient walls.

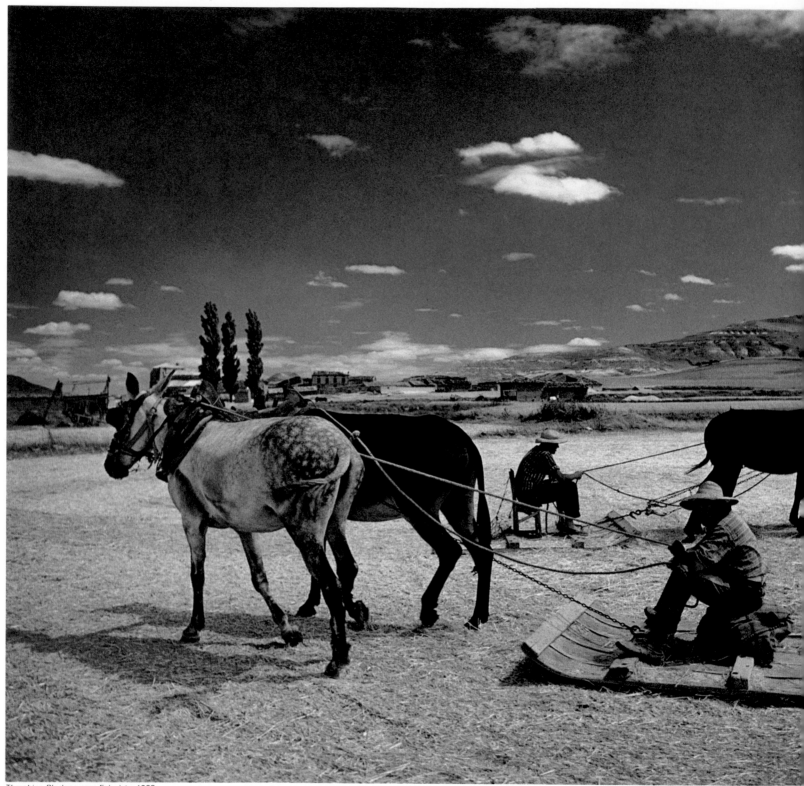

Threshing Sledges near Frómista, 1968

"Castile in July is one golden threshing floor after another, village after village, Biblical and beautiful. This one is typical," says Kuh. When photographing people at work his credo is, "Don't speak unless spoken to; say 'buenos dias' and watch. The Spanish peasant is so secure in his world that he really doesn't care what madness you commit in yours. If it's your folly to take his picture, it's your time and film you're wasting."

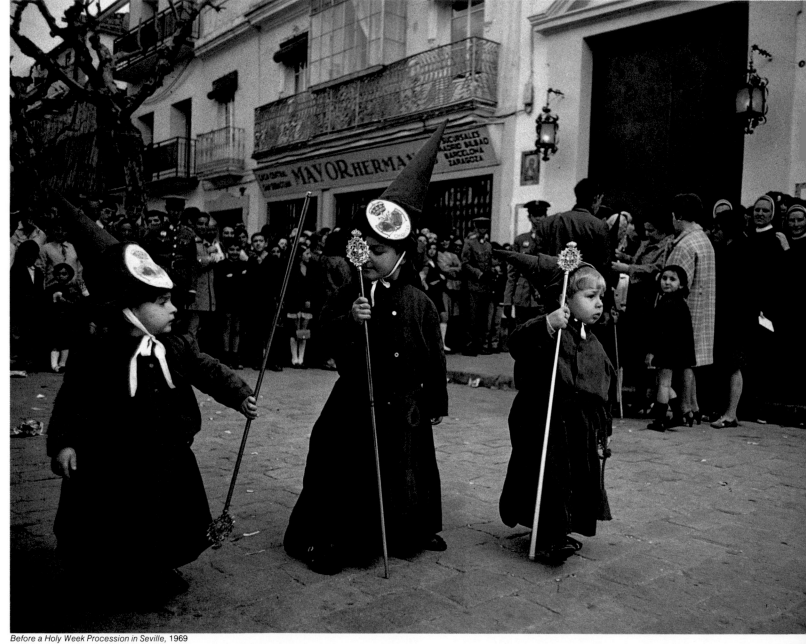

Before a Holy Week Procession in Seville, 1969

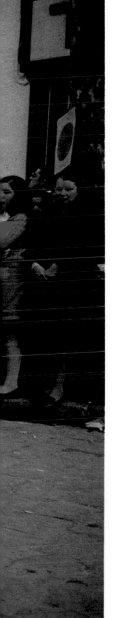

Three little boys in peaked hoods and blue robes (one holding his staff upside down) await the signal to play their parts in Seville's Holy Week procession, at left. Though the occasion is one of great piety, the photograph turns away from solemnity to concentrate on the Spanish enjoyment of the pageantry of their religion.

Again, at right, the presence of a child standing behind his father among a group of penitents focuses on the human element in Seville's Holy Week celebration. The picture was made at twilight with a strobe light. Glancing off the satin robes and silver religious articles, piercing the eye slits of the hoods, the light intensifies the theatricality of the scene.

Celebrants at Twilight in Seville, 1969

171

To celebrate the festival of Corpus Christi, ancient Toledo displays shawls and tapestries from its windows and balconies. Below them, a procession from the cathedral wends through the narrow streets, bearing priceless works of art. Looking up, Kuh's eye was caught by the bannered design that he saw overhead —"a sunshade lit up like stained glass."

Fiesta of Corpus Christi in Toledo, 1969

Such Interesting People 6

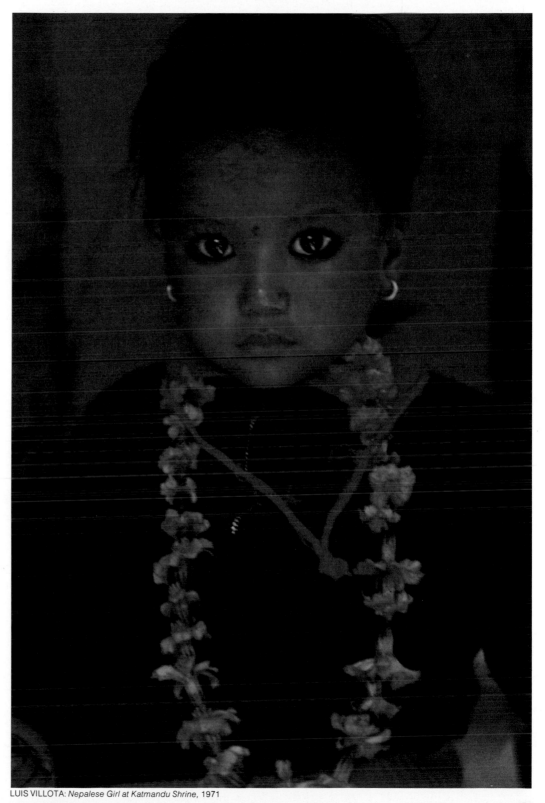

LUIS VILLOTA: *Nepalese Girl at Katmandu Shrine*, 1971

The Elusive Human Element

"When she passes, each one she passes goes 'a-a-h!' " runs the song about "The Girl from Ipanema." And when he visited the beach at Ipanema in Rio de Janeiro and found that the girls were as gorgeous as the song said, Luis Villota (who took the Nepalese photograph on the previous page) naturally began shooting pictures of them. Suddenly a man strode up and tried to grab the camera, accusing Villota of taking indecent photographs. Protesting that he was doing no such thing, Villota held his ground and his camera. His accuser immediately summoned two lifeguards and demanded that they confiscate the camera. At this point, Villota realized that the man was actually after his expensive Nikon, and, in halting Portuguese, he told the guards his suspicion. He convinced them and was able to keep his camera while the would-be thief faded into the crowd.

Luckily, not many tourists will run into such a schemer if they decide to photograph the local inhabitants. And most tourists do decide to, for the spirit of a land is often revealed as clearly through the appearance of its people as through its scenery or monuments. The proof can be seen in Michael Kuh's photographs in Spain, shown in the previous chapter and in the pictures on the following pages, where facial features, attitudes, occupations or costumes mark the subjects as indigenous to their countries. National characteristics differ in fascinating ways: The religious decoration of the little shrine-goer on the previous page—kohl eye make-up, a spot of animal blood on her forehead and a flower necklace—presents a marked contrast to the formal dress of the members of a rural Georgia congregation on page 190.

Differences in national costume are becoming less and less obvious as people the world over forsake the traditional handmade dress of their region for the convenience of standardized, manufactured garments. But some distinctions in clothing remain for the alert photographer to capitalize on. Official uniforms worn both by civilians and by the military vary from country to country; no less revealing is the cut of an ordinary coat in Yugoslavia, an Italian woman's black shawl or the bowler and furled umbrella of a proper London executive. And the human being inside the clothing may provide the most emphatic national flavor of all. No one could fail to distinguish the ramrod stiffness of a British Guardsman from the casual air of an Israeli soldier.

Opportunities for photographing people characteristic of their country surround the traveler from the moment he arrives. There are peddlers in the street, traffic cops at the corners, waiters in the restaurants. It also pays to seek out public events—carnivals, religious celebrations—for there the camera can focus on a variety of local types all gathered to have a good time.

Since most people enjoy having their pictures taken, the tourist with a camera usually gets a good-natured response from his subjects, especially if he asks their permission before shooting. But in some countries, tourists who are

unaware of people's sensitivities have so alienated local inhabitants and officials that more restrictions may be placed on photographers.

The thoughtless curiosity of some tourists in Africa, where travelers often insist on photographing the most primitive-appearing people — not necessarily the most representative subjects — has forced at least one government there to consider desperate measures. An adviser to the tourist industry has proposed artificial villages complete with colorful but acceptably sophisticated "villagers" to pose for pictures. "It may be fake," he says, "but it's a lot less aggravation on both sides." In any part of the world it is polite — and prudent — to inquire whether local pride, custom or religious belief make people unwilling to be photographed. A guide or concierge will know.

Local custom may call for payment to someone who poses for a photographer. A tip is often expected in the American Southwest, for example, as well as in Southern Europe and many parts of Africa and Asia. If a tourist feels awkward about offering money, he can substitute cigarettes, a drink in a nearby pub, or a lift by car. There is also a growing demand for prints of the pictures in place of a tip, and providing them can be a rewarding gesture for the photographer.

Asking people to pose often produces the best pictures — even when they mug. What they do when they consciously perform for the camera reveals the way they would like to be seen. That revelation may give unusual insights into personal and national character. And when the mugging is done, the subject generally relaxes — providing a spontaneous picture that neither he nor the photographer could plan.

Candid photographs, however, can provide intimate glimpses of life and may be easier to get than posed pictures. For close-ups made without the subject's knowledge, a long lens is useful, but there are also other ways to catch people unawares at close range. In a café, for example, the photographer can pretend to be shooting the party at his own table while he is actually focusing on someone who is several tables away. Aiming the camera to the right or left of a subject may cause him to glance away from the photographer to see what is being photographed. When this happens, a quick pivot with a preset camera, and the photographer has a picture with the subject none the wiser. Or a preset camera can be placed on the table and operated with a cable release or self-timer; the camera takes the picture while the photographer enjoys a glass of the local wine.

These techniques for photographing people in distant places are basically no different from ones that work at home. Only their use must change as circumstances dictate. If the photographer's attitude is open, frank and friendly, all barriers will come down, and he will capture on film his impression of a person, a people and a nation. □

The Diversity of Mankind

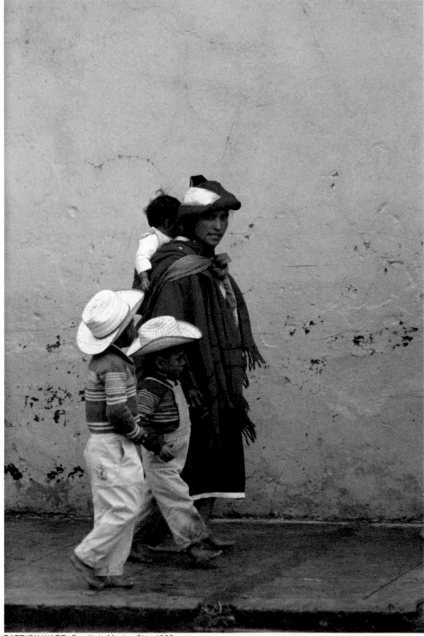

PATRICK WARD: *Family in Mexico City,* 1965

Both diversity and universality characterize the human race— and whichever trait the travel photographer chooses to emphasize when he photographs people, he will have good authority on his side. Henri Cartier-Bresson once said of his own attitude toward the people he photographs: "By no means do I believe that 'man is the same all over the world.' A Chinese and a European have no more in common than the fact that they both have a gender and they both eat and sleep!" Edward Steichen had another view: Writing about the famous "Family of Man" exhibit he assembled that consisted of pictures of people from all over the world, he said it was meant to be a "mirror of the essential oneness of mankind."

The photographers who made the pictures on these and the following pages express that difference in their approach to their subjects. A few have ignored universality to seize on the unique— details of costume, setting or activity— that sets a person apart as someone who lives in a faraway place and observes "strange" customs. But most have used such local touches to develop an atmosphere that places a recognizably human reaction in a recognizably distant setting. Both the photographs on these pages are simply pictures of people; it is only their distinctive clothing or postures that set them apart as dwellers in foreign lands.

Although these barefoot subjects are curiously dressed in a mixture of handloomed Indian clothing and store-bought pants and cowboy hats, the photographer—shooting them against a neutral wall as they hurry along a Mexico City street—has sought to show them not as oddities but simply as a little family, doing what little families the world over do every day.

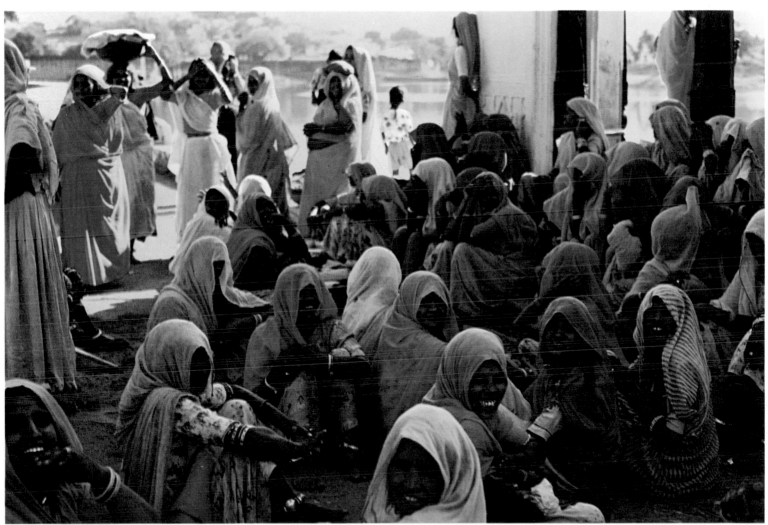

BETTY W. BENNETT: *Women near Udaipur, India,* 1969

Gathered for an afternoon of gossip, a group of Indian women giggle with excitement at spotting a stranger taking their picture. Their garments are exotic and their positions, sitting on the ground, are more Eastern than Western, but their self-conscious reaction is a universal one.

Preoccupied with a case he will soon be arguing, a young barrister in conventional wig and robe emerges from one of London's Inns of Court, a cluster of venerable buildings in which many members of the legal profession have offices. To capture this view, the photographer stationed himself at one of the entrances to the Inns at the time barristers leave their chambers to go to court — and caught the distracted advocate unawares.

ADAM WOOLFITT: *Lincoln's Inn*, 1974

In the doorway of an old French farmhouse, a ▶ grizzled shepherd oils a pair of pliers he will use to make sheep paddocks. The picture is unposed — the shepherd is simply doing his normal work — but the subject was well aware that he was being photographed. Indeed, the photographer had spent five years following flocks of sheep through France's Cévennes mountains in order to be accepted by the shepherds. "Spending time," he says, "is the only way to photograph people."

DANIEL FAURE: *Germain Masoyer, Shepherd, Cévennes, France, 1977*

During a pre-Lenten celebration, two fife-playing revelers dressed in costumes stroll down a narrow, confetti-strewn street in the old section of Basel in Switzerland. The photographer used a slow shutter speed together with electronic flash to create the picture's dreamlike effect of sharp details with blurred outlines.

PAUL MAURER: *Dominos, Basel,* 1974

In his official grand-marshal regalia, the leader of New Orleans' Olympia Brass Band struts past the camera at a parade. The Olympia is one of the last of the marching jazz bands that once played during funeral processions in the city, and whenever it parades, says the photographer, its leader "always has 10 or 15 photographers out taking his picture, so he hams it up for them."

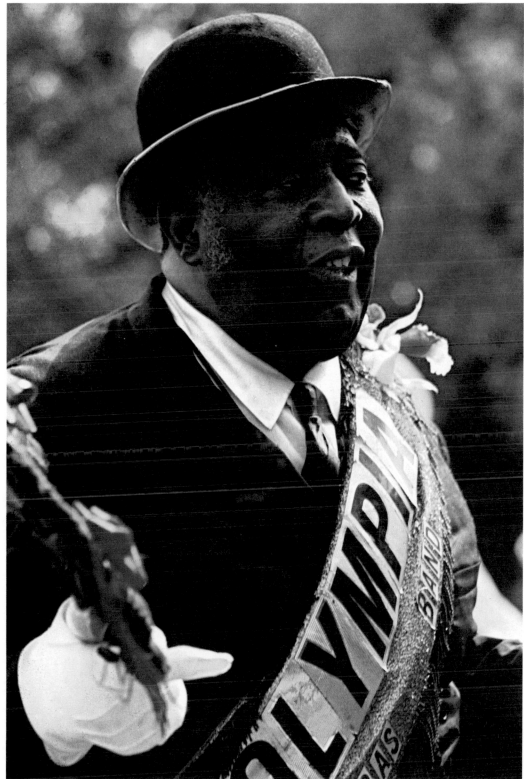

CHRISTOPHER R. HARRIS: *Matthew "Fats" Houston, New Orleans*, 1971

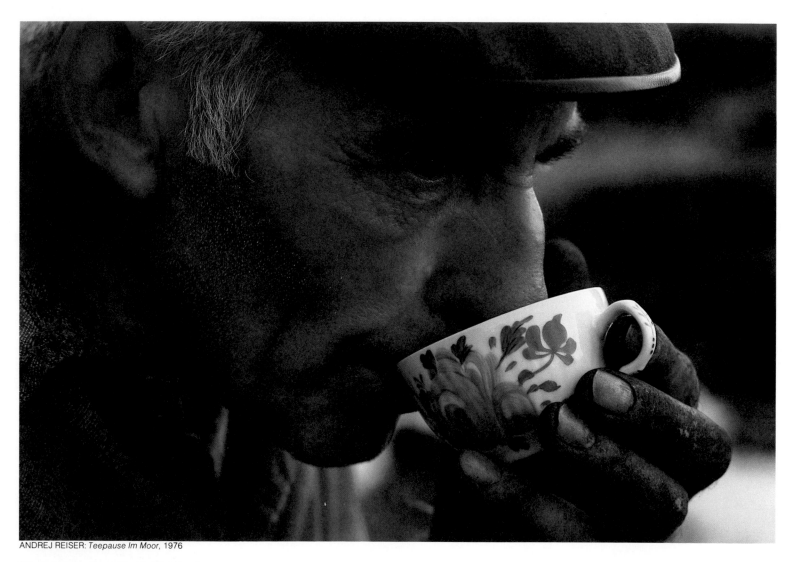

ANDREJ REISER: *Teepause Im Moor,* 1976

*The weathered features and work-stained hand
of a peat cutter contrast sharply with the delicate
porcelain cup he cradles during one of his
regular tea breaks. The cup is painted with the rose
of East Friesland, an agricultural region in
northwestern Germany where the inhabitants drink
more tea than the British.*

Devout Hindu women perform a daily purification ▶
*ritual by bathing — fully clothed to conform to
traditional rules of modesty — in a sacred pool
that is part of an ancient temple complex in Bombay.
Pictures of such rituals provide evocative
glimpses of the customs of unfamiliar peoples, but
before taking them the photographer should
make certain that he will not give offense.*

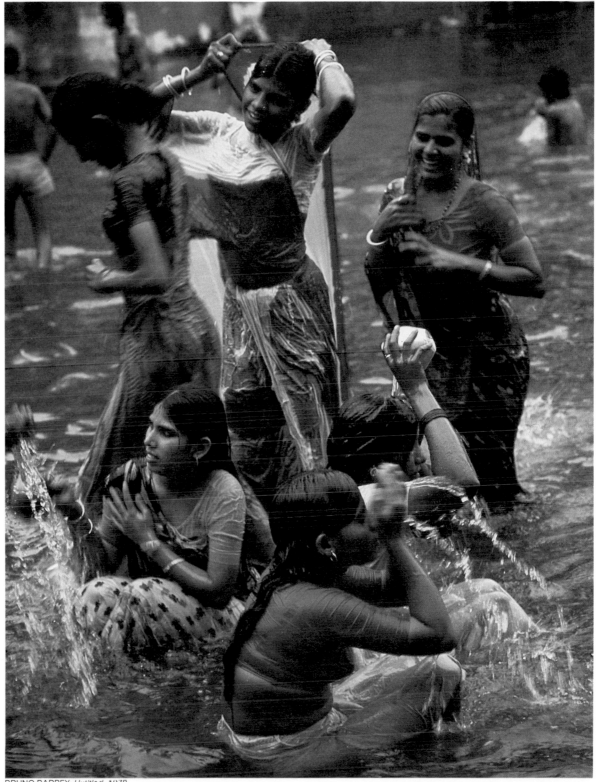

BRUNO BARBEY. *Untitled*, 1978

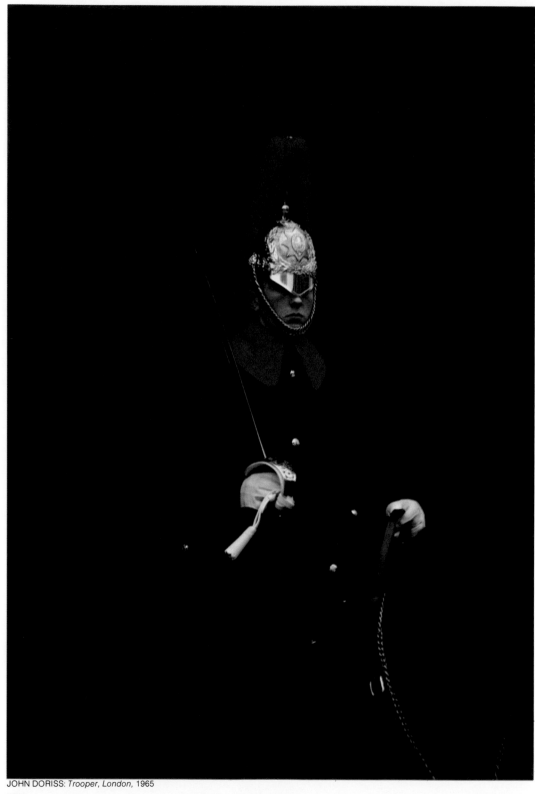

One eye barely visible beneath his burnished visor, an impassive young mounted sentry sits ramrod-stiff in the saddle, ready to move out into the changing-of-the-guard ceremony at Whitehall, in London. "The trooper knew his picture was being taken, of course," says the photographer. "People abroad sometimes do seem sensitive when we Americans photograph them as if they were oddities. To overcome this problem, I have my wife stand in front of a subject while I focus my camera. When I'm ready, my wife moves away and I can catch the subject more naturally."

JOHN DORISS: *Trooper, London,* 1965

LISL DENNIS: *Wadi Rum*, 1979

The colorfully embellished weaponry of a Jordanian desert policeman—given extra emphasis in this close-up with a wide-angle lens (page 187)—stands out sharply against a cloudless sky and bleak desert background. The policeman posed for the picture and demanded payment, but the photographer, a woman, got him to accept a friendly kiss and a ride home instead.

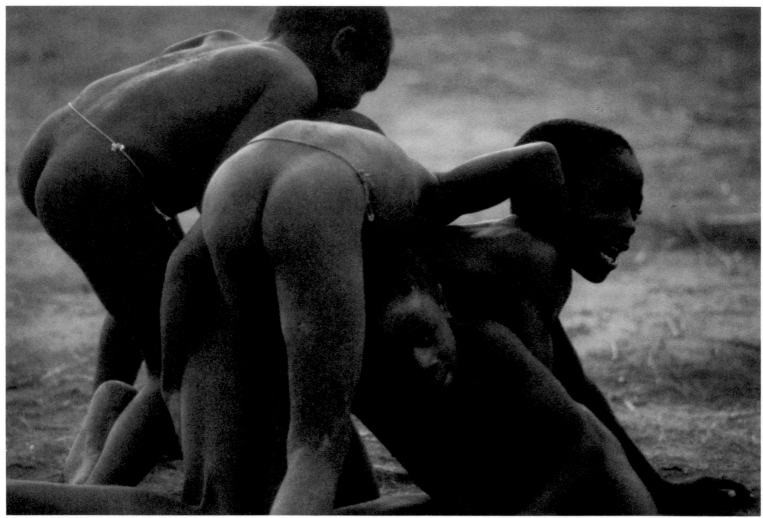

MICHAEL K. NICHOLS: *Saramaccan Children Playing Soccer, 1980*

*In a village deep in the interior of the South
American country of Surinam, children interrupt their
play to scramble for a Frisbee tossed by the
photographer. The children are descendants of
slaves who escaped from coastal plantations more
than two centuries ago. Here, as in many situations,
the children's spontaneity made them better
subjects than adults for the travel photographer.*

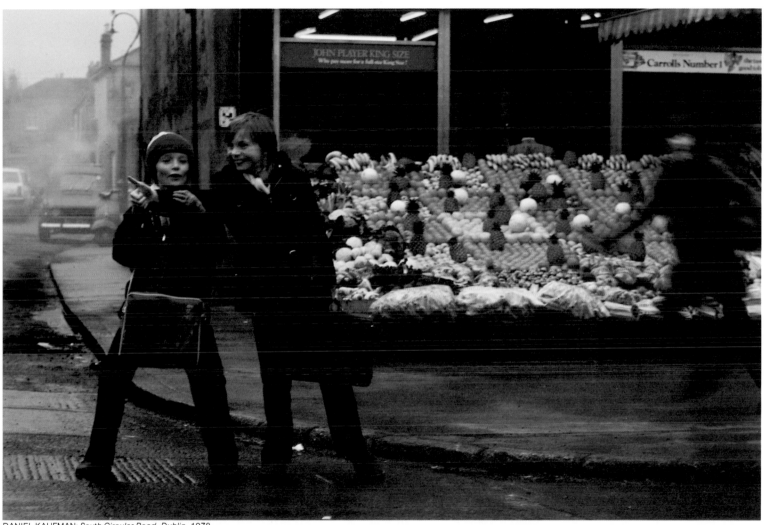

DANIEL KAUFMAN: *South Circular Road, Dublin,* 1978

The yellows and oranges of a Dublin fruit stand,
offering a welcome splash of color in the gray Irish
spring, were what attracted the photographer to
this scene. As he was composing the picture, the
schoolboys ran into the frame — the boy on the
right moving so quickly that the slow shutter speed
left him a blur — and transformed a pleasant
travel picture into a memorable one.

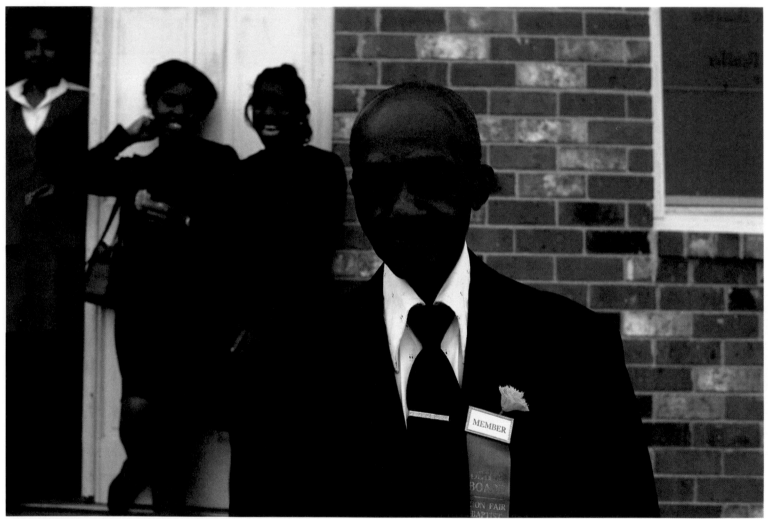

BILL WEEMS: *Southern Church Elder*, 1977

Outside a country church in coastal Georgia, a respected elder poses for an informal portrait, while behind him two teen-age girls laugh and preen for the camera. The contrasts in age and attitude offer a provoking insight into the changes that are overtaking the traditional ways of the rural South.

STEPHEN GREEN-ARMYTAGE: *Greek Priests,* 1965

Struck by the color contrast between the black-garbed priests and the whitewashed houses on the Greek island of Andros, the photographer took this picture when he spied five priests walking down a narrow street, their billowing robes and high-crowned headgear making a patterned silhouette that is incontrovertibly Greek.

In the city of Udaipur in northwestern India, two men squat before the door of a warehouse to play the ancient game of shatranj, an ancestor of chess. The postures and costumes of the men, together with the English-language sign over the door, emphasize India's mixed heritage of East and West.

RAGHUBIR SINGH: *Chess Players, Udaipur,* 1977

ROLAND AND SABRINA MICHAUD: *Untitled*, 1973

This melee of exotically garbed riders and mettlesome horses is characteristic of boz-kashi, a game played by Turkmenian nomads on the steppes of northern Afghanistan. The game celebrates a warlike equestrian tradition that dates back to Genghis Khan.

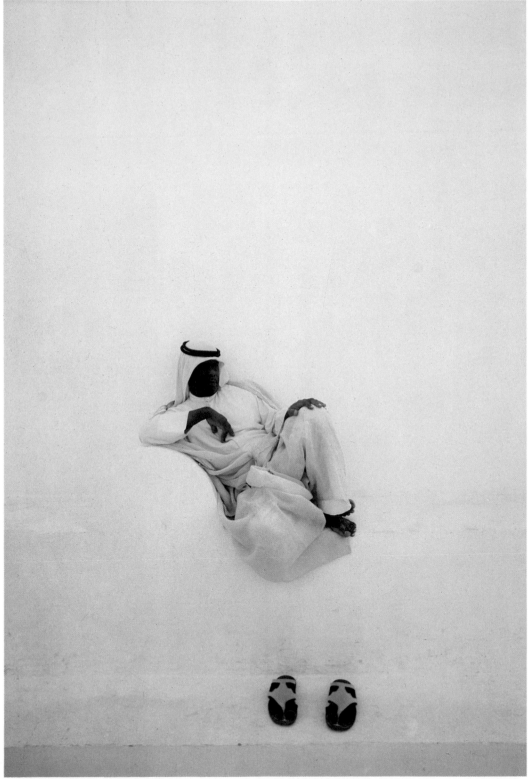

ROBERT AZZI: *Petitioner in Bahrain,* 1975
194

In a courtyard near Bahrain's royal palace, a
barefoot petitioner awaits the arrival of Emir Isa, the
ruler of the tiny oil emirate. The whiteness that
envelopes the patient supplicant suggests the
searing heat of the Arabian peninsula. Like most
good travel photographs, this one presents a
characteristic feature of an unfamiliar place in a
clear but slightly unconventional fashion.

Clichés Revisited **7**

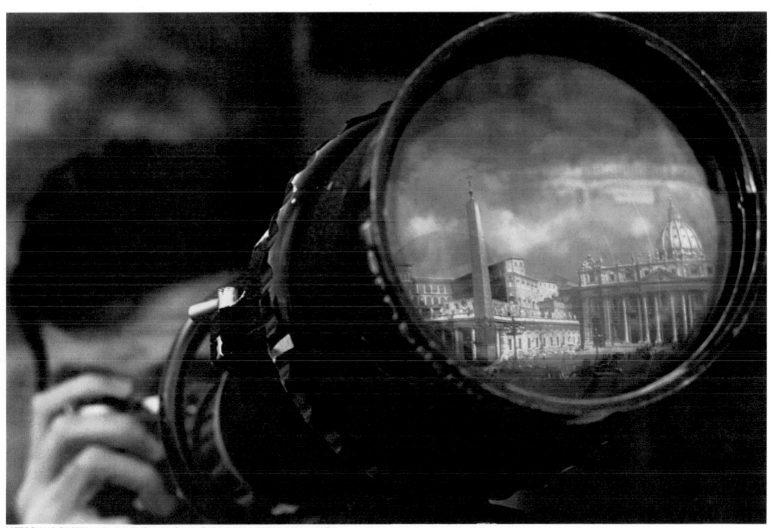

VITTORIANO RASTELLI: *St. Peter's Square, Rome, Reflected in a 1,000mm Lens,* 1970

Escaping the Tyranny of the Familiar

Keats's lamentation "Where's the cheek that doth not fade,/Too much gazed at?" might well be applied to travel photography. Every monument and tourist attraction seems to have faded for having been too much seen and photographed. Too often the tourist himself approaches a scene with his inward eye glazed by the postcards, travel posters, matchboxes, calendars and neighbors' pictures he has had to see before. Then he photographs the place and perpetuates the cycle by producing yet another tired view—a cliché. The very word cliché entered the English language through photography; it comes from the French term that is applied to photographic negatives and other means of reproducing a single image over and over again.

And yet, professional postcard makers and amateur photographers together have not exhausted all the aspects of monuments, buildings and landscapes that have become clichés only through their photographs. Although there are no hard rules for avoiding the trite, a few hints from the experience of professional photographers can be of help. These fall into two categories. The first concerns the use of equipment; the second, the use of imagination.

Almost any extra equipment can make possible a fresh view of a stale scene. Even a clamp to hold the camera can lead to an unusual angle or suggest the advantage of a time exposure; a flash unit may provide distinctive lighting *(pages 206-207)*. But probably the most useful aids are lenses of short and long focal lengths, which can make a small shift in camera position cause a tremendous alteration in the look of a scene, even when it is shot with the same lighting and from almost the same angle used by countless others.

The focal length of a lens makes a great difference in the picture partly because it influences depth of field but mainly because it controls the apparent perspective. A short lens's great depth of field is often exploited to keep a nearby object sharp while major interest is focused on the background; conversely, the long lens's limited depth can make unwanted objects in a scene so blurred they are never noticed. These effects of focal length are often overshadowed by the changes it introduces into the relative sizes and positions of objects. If the photographer backs off from his subject, a long lens can cause a distant object to loom large and strangely close to one in the middle distance *(pages 202-203)*; a short lens does the opposite if the photographer moves in close—nearby objects look large while distant ones appear oddly small and far away. An extremely short lens may cause distortions in the shapes of objects near the edges of the image—an effect that can be used to advantage with some subjects *(pages 204-205)*.

Even without extra accessories, manipulation of the camera and the film provides the photographer with room for experiment. Underexposure, for example, can silhouette a monument if its contour is more interesting than its detail *(pages 212-213)*.

More important than the use of photographic equipment is the use of imagination. Do not be hampered by the "six-foot complex," which afflicts many a photographer away from home: He stands squarely in front of every monument and shoots all his pictures from eye level, five to six feet above ground level. Every shot looks like every other one. Walking around a subject, getting close to it, stalking it like living prey, can reveal startling aspects. Viewed by itself, the metalwork of the Eiffel Tower's massive base becomes a giant symbol of the industrial age. Seen from high above, the Basilica of St. Mark's takes on a fanciful, almost illusory quality.

The imaginative photographer finds ways to take advantage of possibilities others might dismiss. Stuck in a building-jammed street, he detects an unobstructed view available from the roof of a nearby hotel; a request to the hotel manager can gain him permission to make rooftop shots.

The free use of imagination depends on the photographer's feeling for his subject. The photographer who is awed by a monument or indifferent to it is bound to produce no more than a respectful or an indifferent picture. Once the tourist is at ease with his subject, he may be able to use to advantage the accidental elements of a scene, which sometimes seem to present insurmountable difficulties. Many photographers find that the encroachments of the 20th Century make it impossible to capture a pristine view of a classical structure. The smog and crowds of present-day Athens present just such a problem for photographers of the Parthenon. Richard Misrach, however, shot a memorable Parthenon portrait (pages 206-207) that incorporates the hazy nighttime lights of the city, a way of showing that the ancient temple is "still living, breathing and changing in the middle of Athens." Another approach might be to frame a monument in a gateway (page 210) or to show it reflected in the lens of a companion's camera (page 197).

The photographer's ability to be mentally limber is what gives the pictures in this chapter their character, and anyone can acquire that limberness. The effort will more than repay him, for he will have achieved the highest level of travel photography. Not only can he retrace his journey again and again through his pictures, he will have the satisfaction that comes of creation, and in the end a collection that is as uniquely personal as his signature. □

The Postcard View, a Point of Departure

Picture postcards are as much a part of traveling as air tickets or passports. Introduced in 1891 by a Frenchman from Marseilles, Dominique Piazza, they now function not only as vehicles for messages to the folks back home but also as decorative exit tickets, receipts that prove one has been somewhere—and emergency substitutes for the photographic memories most travelers record with their own cameras and their own viewpoints.

As photographs, postcards do present straightforward views and may capture the essence of a local mood. But the views, being standardized, are clichés, and they suffer from a propagandistic tendency to show that all is well under a heavenly, eternally blue sky.

How much more the traveler might accomplish with his own camera is indicated on the following pages, which show the same postcard scenes that are illustrated at right—recorded, however, by professionals who found ways to make the familiar views as fresh and exciting as they were in the beginning.

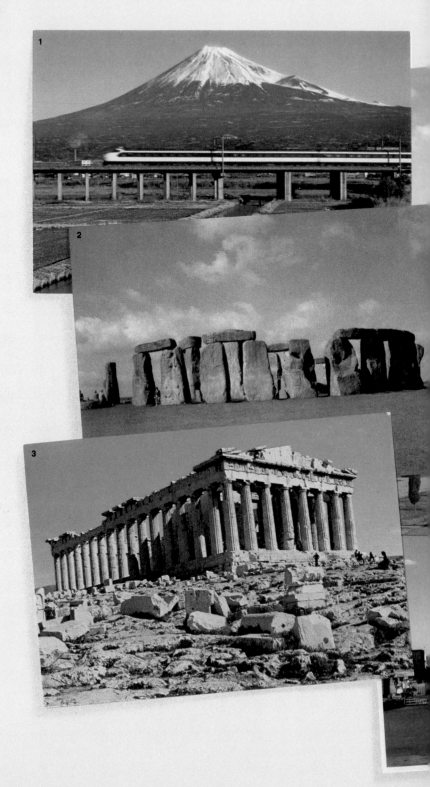

1 **Mount Fuji, Japan**

2 **Stonehenge, England**

3 **The Parthenon, Greece**

4 **St. Mark's Square, Venice**

5 **Taj Mahal, India**

6 **Manhattan Skyline, New York**

7 **Neuschwanstein Castle, Bavaria**

8 **The Leaning Tower of Pisa, Italy**

9 **Eiffel Tower, Paris**

10 **Machu Picchu, Peru**

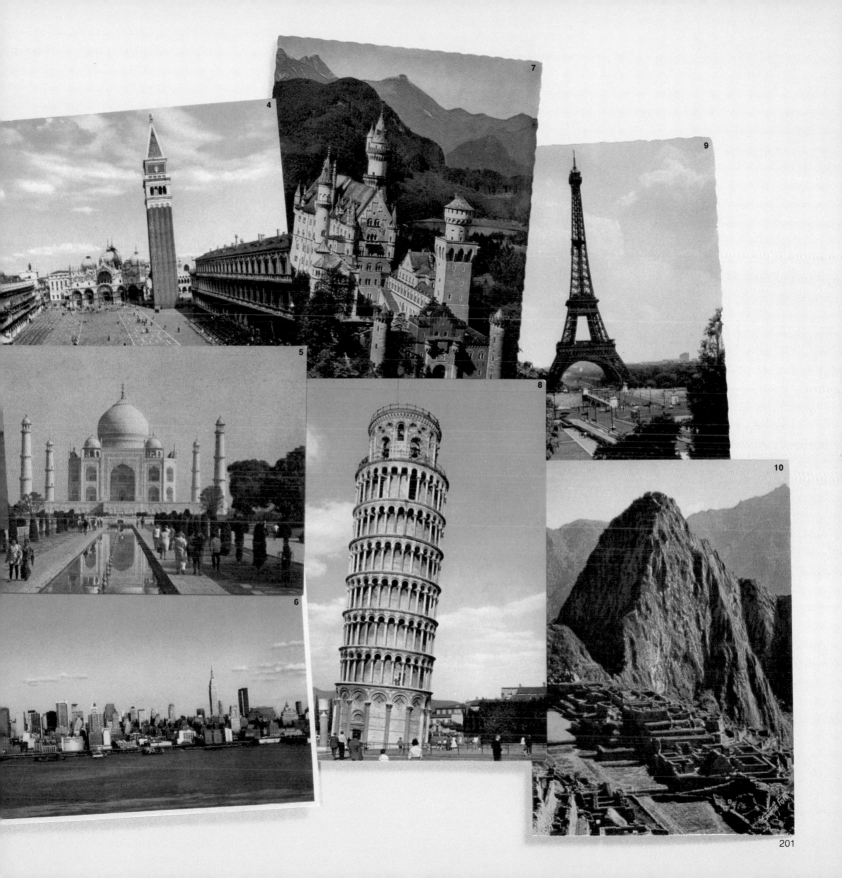

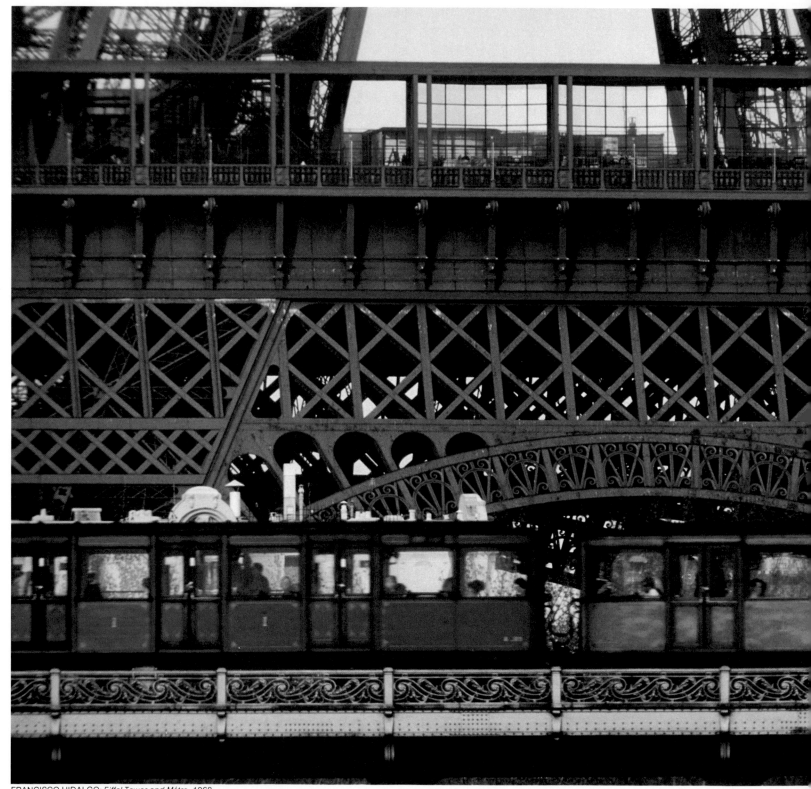

FRANCISCO HIDALGO: *Eiffel Tower and Métro*, 1968
202

Two cars of the Paris Métro roll past the arching, filigreed ironwork that unmistakably identifies the Eiffel Tower, even when it is seen only in part. The photographer stood across the Seine River, hundreds of yards from the tower, and used a 400mm lens to get this novel view of its enormous base. The foreshortening effect of the long focal length makes the Métro cars—actually on a bridge crossing the river—appear to be riding on a ledge of the massive structure behind them.

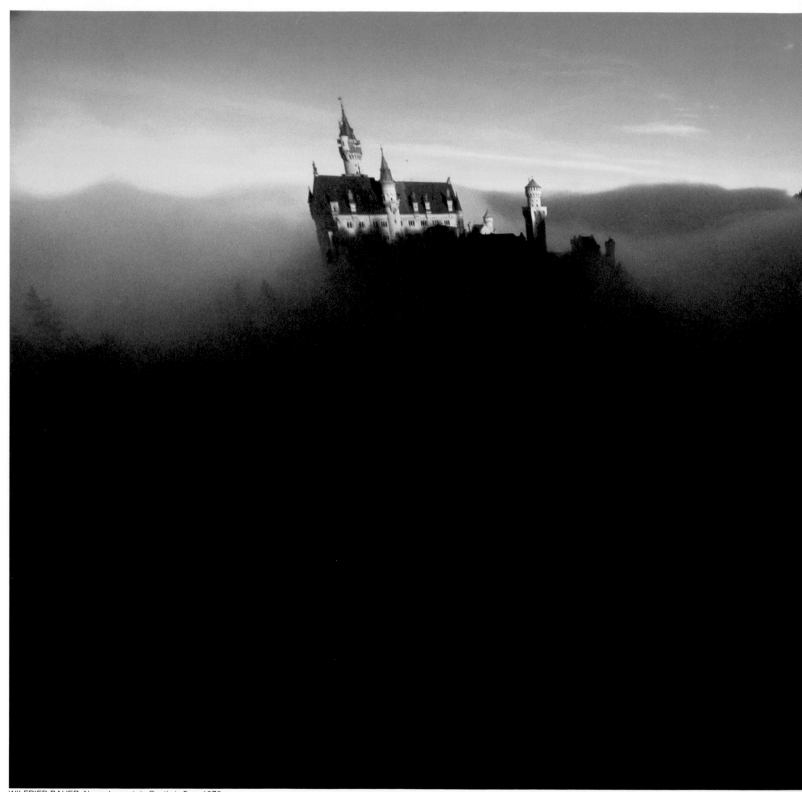

WILFRIED BAUER: *Neuschwanstein Castle in Fog,* 1976

Like a fairy-tale palace, the graceful turrets and spires of Neuschwanstein Castle float above the ground fog in the Bavarian Alps. The castle has embodied Teutonic fantasy for tourists — and photographers — ever since mad King Ludwig II of Bavaria finished it in 1886, the year he drowned himself after being deposed for just such fanciful indulgences. Photographer Bauer visited Neuschwanstein 10 times before capturing this extraordinary vista, in which the dense fog and the distortions of an extreme wide-angle lens seem to remove the castle from everyday reality.

A bronze bell ringer and the curve of a metal support on a clock tower high above St. Mark's Square struck the photographer as being more Venetian than the lion-with-a-book or St. Mark's-with-pigeons postcard views. "The statue and the bell were floating on the city," he says. "The bell ringer seemed like a god." To achieve the floating effect in the photograph, he used an extra-wide-angle fisheye lens, which minimized and curved the background of the city beneath.

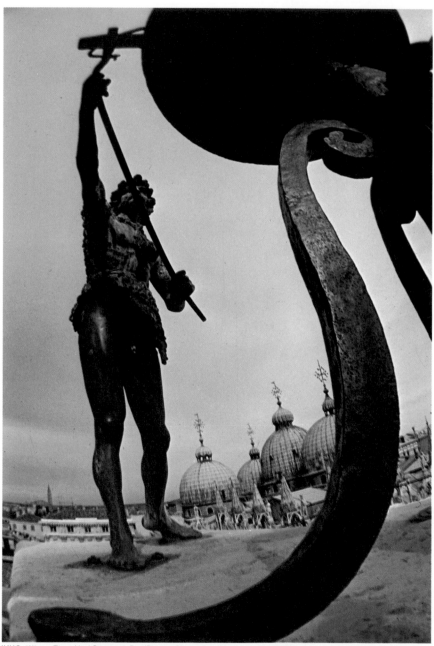

IKKO: *Where Time Had Stopped: Bell Ringer, Piazza San Marco, Venice, 1964*

Washed clean by a winter rain, the ruin of the ▶ Parthenon glistens in light that seems to come from the moon and the streets of nighttime Athens. In fact, photographer Richard Misrach lit the temple with an electronic flash, which he fired 30 times from various points inside it while he left his camera shutter open for almost 30 minutes. (His legs are visible as shadows in some of the pools of light that the flash created on the floor.) Misrach had to secure permission to shoot at night and to work in the normally roped-off interior of the Parthenon.

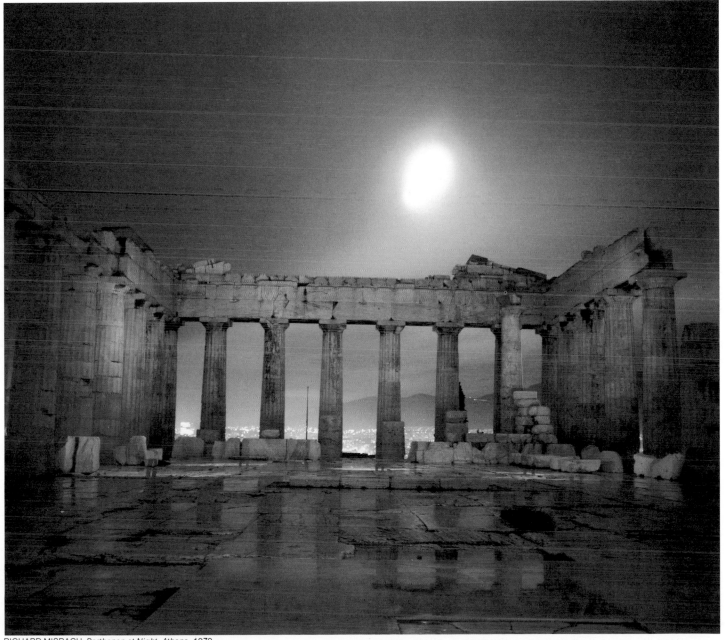

RICHARD MISRACH: *Parthenon at Night, Athens,* 1979

BURT GLINN: *Sunrise, Mount Fuji*, 1961

A colored woodcut by the 19th Century Japanese artist Hokusai inspired this spectral view of sunrise over Mount Fuji. The photograph was taken from a Buddhist monastery on Mount Shichimen, about 20 miles to the west, a sacred spot that at certain times of the year offers a view of the sun rising right out of the crater of the dormant volcano. The photographer rose before dawn and followed the pilgrims as they went out to worship before Fuji, "The Great One."

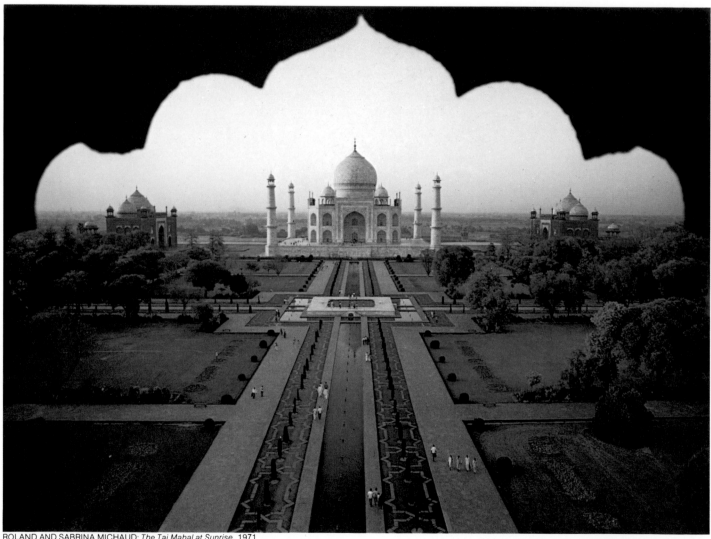

ROLAND AND SABRINA MICHAUD: *The Taj Mahal at Sunrise,* 1971

The Taj Mahal's great gateway gracefully frames India's most famous building and enhances its ethereal lines. The husband-and-wife team who made the photograph chose a general view instead of a detail because they felt that the beauty of the place lies not so much in the romantic Taj itself as in the harmonious combination of structures, gardens and pools.

Almost as familiar as The Leaning Tower of Pisa ▶ is the truism that "everything is relative." Both commonplaces have been put to uncommon use in this picture of an upright tower being circled by leaning Pisans and other tourists. To take the picture, the photographer simply tilted his camera until the vertical edges of the frame became almost parallel to the sides of the tower.

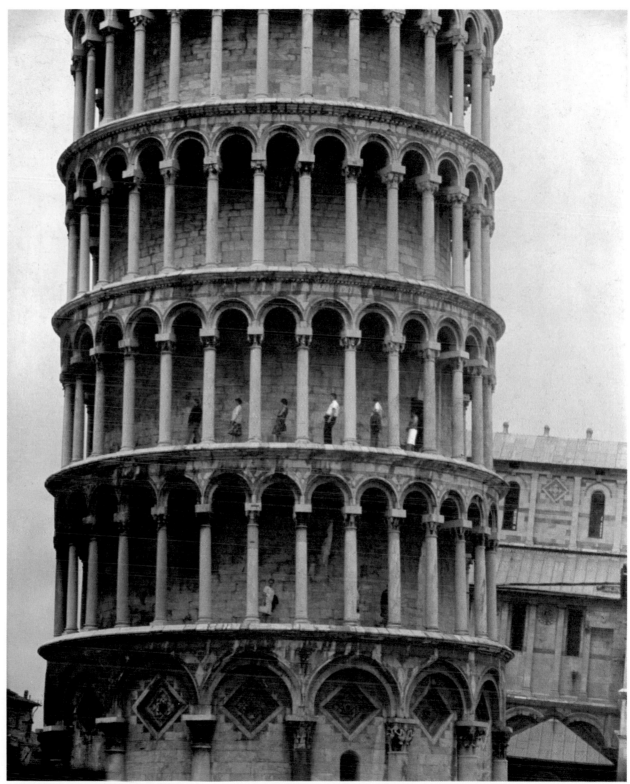

RALPH CRANE: *The Leaning Tower of Pisa,* 1956

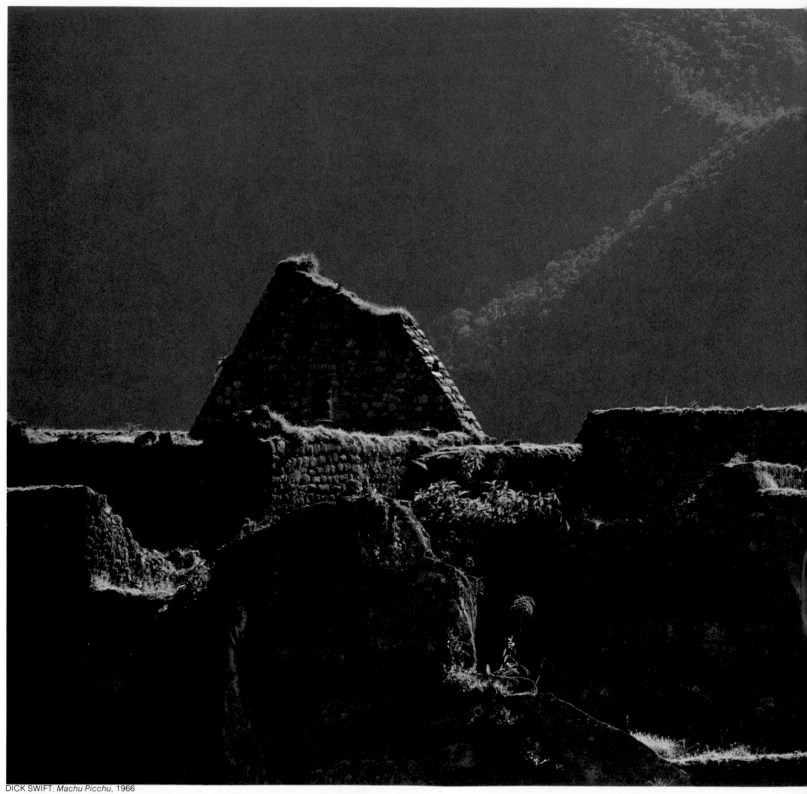

DICK SWIFT: *Machu Picchu,* 1966
212

High in the Peruvian Andes, the early-morning sun reaches through a mountain pass to highlight a profile of the Inca ruin of Machu Picchu. The photographer bypassed the usual day tour of the once-holy city and spent a chilly night camped out inside its walls to get this unusual picture. As dawn illuminated the moss-covered masonry and the surrounding peaks, he slightly underexposed a view of the crumbling structures to emphasize their sunlit outlines, which are echoed in the shapes of the mountains beyond.

The setting sun gilds the towers of midtown
Manhattan, transforming the workaday city into a
20th Century Midas' kingdom aglow with magical
incandescence. From a vantage point in New
Jersey, photographer Jay Maisel took this picture
as part of a long-time personal project to capture the
essence of the city in a series of "sunsets without
suns" — pictures of the richly colored light of day's
end reflected by the walls and windows of
Manhattan. Here, with the mirrored sun midway
down the Empire State Building, the smog over
Queens contributes a contrasting background to set
off the dazzling majesty of the metropolis.

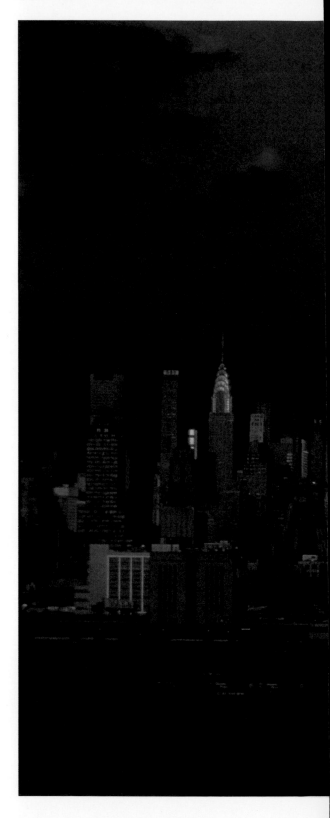

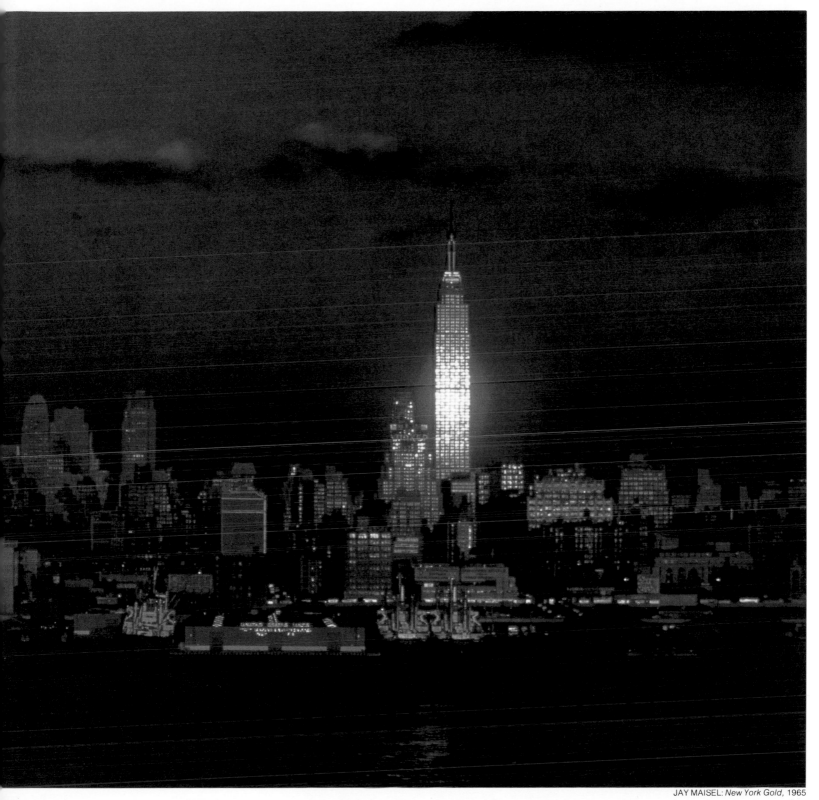

JAY MAISEL: *New York Gold*, 1965

SONJA BULLATY AND ANGELO LOMEO: *Stonehenge,* 1971

*A sense of mystery prompted this twilight look at
Stonehenge. "Our feeling," recalls Sonja Bullaty,
"was that it transcended people and time. This
eternal cosmic quality seemed best conveyed at
dusk, with a full moon rising." The husband-
and-wife photographers stood outside the stone
circle facing east and caught the moonrise
just as the last rays of the sun lit up the stones.*